exploring textures in watercolor

a hands-on approach

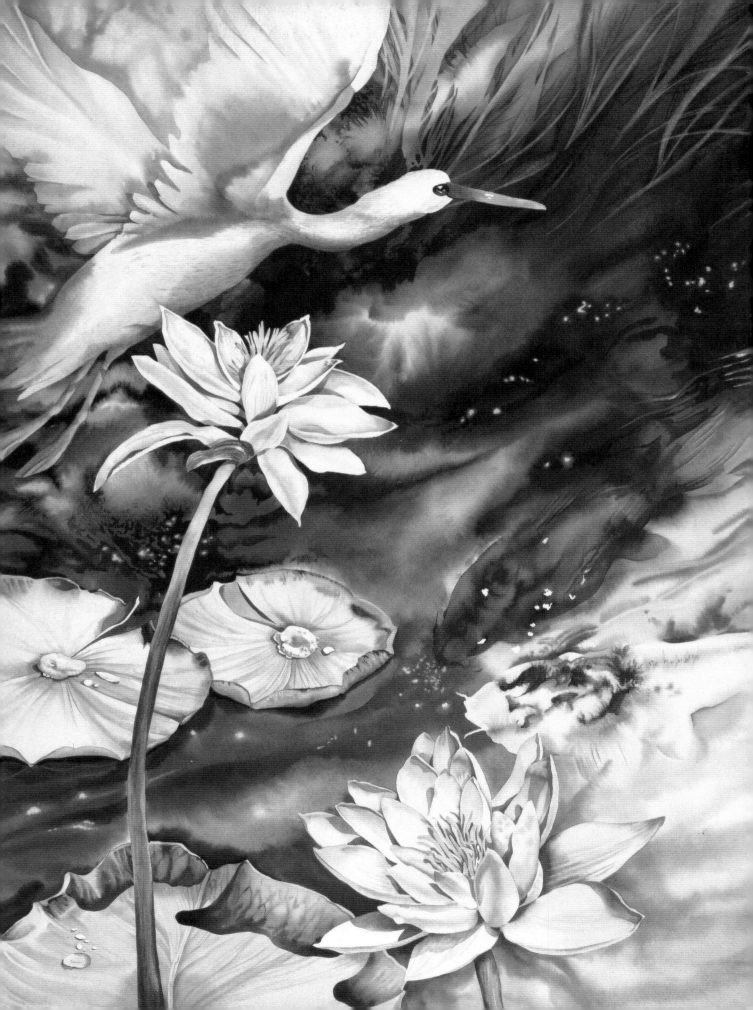

exploring textures

in watercolor

a hands-on approach

Joye Moon

NORTH LIGHT BOOKS
CINCINNATI, OHIO
www.artistsnetwork.com

Photo by Joe Sienkiewicz

about the author

Joye Moon is a nationally recognized artist and art instructor. She is a signature member of the National Watercolor Society and the Mississippi and Wisconsin Watercolor Societies. She has displayed her work in solo exhibits in Colorado, Georgia, Florida, Illinois, Wisconsin and Washington DC. Her work has won top awards in national and international juried exhibits, and has appeared in such publications as *American Artist, Watercolor Magic, Splash 8* (North Light Books), *Searching for the Artist Within* (Bayfield Street Publishing), and *100 Ways to Paint Flowers & Gardens* (International Artist).

Joye has conducted workshops throughout the U.S. and in Mexico, France, Italy, Spain, Greece and the Bahamas. To see Joye's current artwork and a listing of art workshops around the world, visit her website at www.joyemoon.com. Joye lives with her husband, Dave, and maintains her home studio along the shore of Lake Butte des Morts outside Oshkosh, Wisconsin.

● *Moonlight (page 2)*
Watercolor on 140-lb. (300gsm) cold-pressed watercolor paper
30" × 22" (76cm × 56cm)
Collection of Kenneth and Beth Campshure

may quote brief passages in a review. Published by North Light Books, an imprint of F+W Publications, Inc., 4700 East Galbraith Road, Cincinnati, Ohio, 45236. (800) 289-0963. First Edition.

Other fine North Light Books are available from your local bookstore, art supply store or visit our website at www.fwpublications.com.

12 11 10 09 08 5 4 3 2 1

DISTRIBUTED IN CANADA BY FRASER DIRECT
100 Armstrong Avenue
Georgetown, ON, Canada L7G 5S4
Tel: (905) 877-4411

DISTRIBUTED IN THE U.K. AND EUROPE BY DAVID & CHARLES
Brunel House, Newton Abbot, Devon, TQ12 4PU, England
Tel: (+44) 1626 323200, Fax: (+44) 1626 323319
Email: postmaster@davidandcharles.co.uk

DISTRIBUTED IN AUSTRALIA BY CAPRICORN LINK
P.O. Box 704, S. Windsor NSW, 2756 Australia
Tel: (02) 4577-3555

Library of Congress Cataloging in Publication Data
Moon, Joye
 Exploring textures in watercolor : a hands-on approach / by Joye Moon.
 p. cm.
 Includes index.
 ISBN 978-1-60061-028-8 (hardcover : alk. paper)
 1. Watercolor painting--Technique. 2. Texture (Art) I. Title.
 ND2365.M66 2008
 751.42'2--dc22 2008015607

Edited by Vanessa Lyman
Production edited by Mary Burzlaff
Designed by Guy Kelly
Production coordinated by Matt Wagner

Metric Conversion Chart

To convert	to	multiply by
Inches	Centimeters	2.54
Centimeters	Inches	0.4
Feet	Centimeters	30.5
Centimeters	Feet	0.03
Yards	Meters	0.9
Meters	Yards	1.1

Milo and I painting side by side in San Gimignano, Italy, 2000.

dedication

To my husband, Dave. Since I was sixteen years old, your unwavering support and encouragement has enabled me to live my life as an artist. Thanks for joining me in the fun!

To my adult children, Nathan and Rachel. Your enthusiasm, zest for life and appreciation for the arts inspires me every day.

To Milo Cushman. Milo joined one of my local watercolor classes after retiring early from his engineering career because of cancer. Milo, with his wife Vonnie and daughter Kerrie, joined Dave and me on our first two trips to Italy and France. He was the life of the party, either entertaining us by playing the piano in a hotel lobby or dancing in the street with our beautiful guide. Milo lived large. He brought enthusiasm and love into his painting, music and the lives of everyone around him. Milo lost his battle with cancer on New Year's Eve 2006. I'm honored to call him my friend and fellow painter. I smile with tears in my eyes when I think of him.

● *Along the Arno River (top)*
Milo Cushman
Watercolor on 140-lb. (300gsm) cold-pressed watercolor paper
10" × 12" (25cm × 30cm)
Collection of Vonnie Cushman

● *Ocean Breeze*
Milo Cushman
Watercolor on 140-lb. (300gsm) cold-pressed watercolor paper
11" × 15" (28cm × 38cm)
Collection of Vonnie Cushman

acknowledgments

To my parents, Glenna and Robert Meyer, for encouraging and fostering my young dream to become an artist.

To my mother- and father-in-law, Ruth and Warren Moon, for coming to every art exhibit I've had since I was sixteen years old, as well as for their constant support. I wish they were still here to share in the completion of this book.

To my "Art Gals" Joanie Mosling, Pat Reiher, Margot Castle and Deb Bartlet for all the laughs and art adventures.

To Don Stolley, whose photography and computer expertise guided me through this process. Don also contributed photography with some shots in Chapters 3, 5 and 6.

To my editors, Vanessa Lyman and Mary Burzlaff, whose abundant knowledge and guidance were instrumental in completing this book.

A special thanks to Karlyn Holman and Steve Quiller for unselfishly sharing your artistic knowledge and prompting me to explore the world with my art groups. Your caring friendship and your encouragement in writing this book has been invaluable. Through your examples, I've learned what it means to dedicate myself as an artist.

table of contents

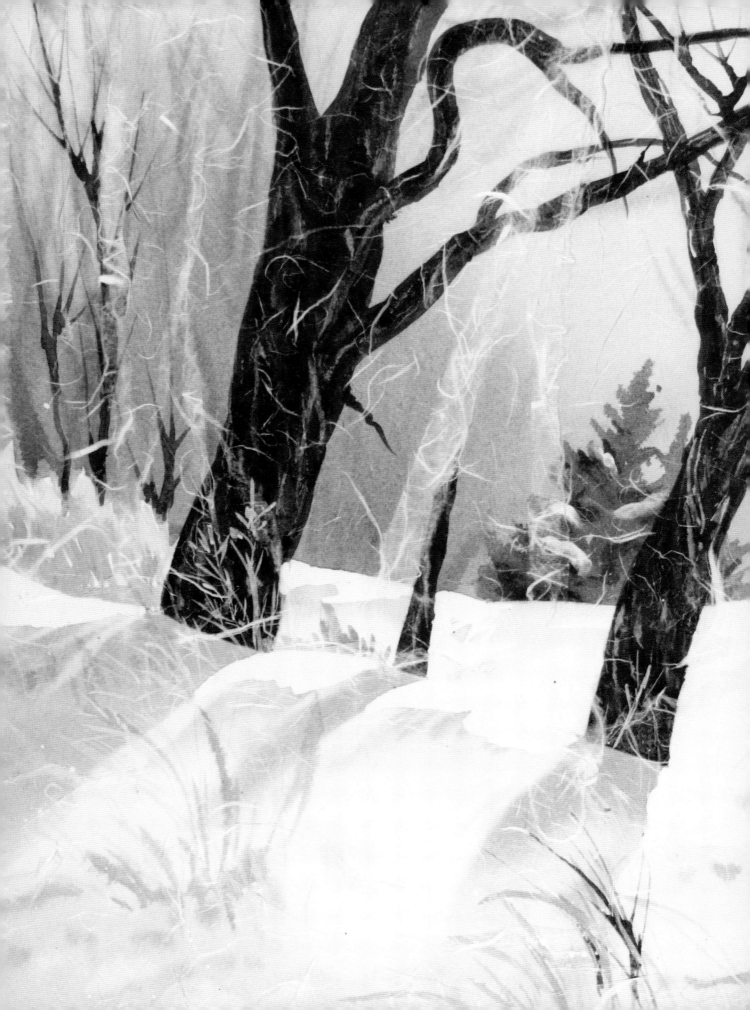

● *March Snow Shadows, Rio Grande*
Stephen Quiller
Acrylic and watermedia
20" × 29" (51cm × 74cm)
Courtesy of Quiller Gallery, Creede, Colorado

foreword

This book by Joye Moon is long overdue and greatly needed by all aspiring watercolor painters. Joye is an artist and educator who has been diligently painting and touching many painters' minds and inspiring their souls for more than twenty-five years. I have experienced Joye's passion for art and zest for life, and her spirit is infectious.

I am amazed at Joye's versatility as a painter. Her work has a lightness of touch, beautiful and expressive color, and a distinctive mark. Her work explores the various facets of watercolor—loose to tight, wild to controlled, brilliant to neutralized color, large to small formats. Joye is well-known for her splashy, large, wet, painterly florals. In addition, her figure and portrait work is very sensitive and penetrating—reason enough for the numerous awards.

When it comes to teaching and writing, Joye is an outstanding, clear and articulate communicator. She loves people and shares freely of her knowledge. Through the years, she has touched countless lives. Her depth of knowledge, talent, positive interaction with workshop participants are qualities that make her an excellent instructor and are qualities that will come through in this book.

Stephen Quiller

—Stephen Quiller

introduction

As a creative person, I've explored various art mediums such as pottery, jewelry making, printmaking and a variety of painting mediums, but my heart has always been filled with a love for watercolor. When I was about four years old, my mom gave me a children's art book to paint. It had those little color dots that were activated by touching the dots with a brush full of water. The magic of that dot bursting into a fluid mass of watercolor paint intrigued and amazed me then, and the magic of watercolor still captivates me more than fifty years later. With this book, I hope to share my knowledge of this incredible medium with you so that you, too, can also experience the fun and magic of watercolor and all it has to offer.

When I was asked as a child, "What do you want to be when you grow up?" my answer was, "An artist—but I am one already." A childlike enthusiasm has always propelled me creatively.

Over the past twenty years I've presented more than one hundred national and regional watercolor workshops throughout the country, and more than a dozen plein air workshops in the Caribbean, Europe and Mexico. I design win-win projects to encourage beginning students and construct projects using new methods and techniques to challenge advanced students. My goal has always been to evaluate a students' artwork quickly and create ways to move them along their artistic paths. This book is a visual guide that will take your work to the next level and make you a more confident artist.

The focus of this book is to explore a multitude of surface qualities and textures that can be achieved using watercolor. Starting with chapter one, you can build a strong foundation with a simple composition, then develop your painting skills by completing the projects in successive chapters. Each project explores different subject matter and gives you the chance to challenge yourself with realism, semi-abstraction and abstraction. Try spraying, splattering and sculpting paint as well as using plastic wrap, wax paper, aluminum foil and twine to create a variety of textures that will enhance your artwork. Your knowledge of new methods and techniques will build with each chapter, giving you the confidence to paint independently.

I've been fortunate to live my life as an artist. "Paint With Passion" has been my mantra. I hope this book will help you grow as an artist. Sharing what we love feeds our spirit.

● *Alley of Saint-Paul de Vence, France*
Watercolor on 140-lb. (300gsm) cold-pressed watercolor paper
11" × 7" (28cm × 18cm)
Private collection

special features

re-surfacing your techniques
By simply changing your surface, you can drastically change a technique. Many new surfaces are available for watercolorists, and they can produce wonderfully diverse textures. Throughout the book, you'll find exercises that demonstrate how using the same techniques can on a new surface express a different side of you.

bringing art to life
Just as you create art, art can help re-create you. It can take you places—emotional and physical—that are unexpected. Throughout the book, you'll find my suggestions and stories about taking advantage of those opportunities and creating a life that is a rich tapestry.

discovering
the basics

Learning a new medium can be a challenge, especially if you're a beginner. I hope to help you build your skills quickly by introducing you to some important methods and techniques every artist needs to know. In this section, you'll learn to paint with a wide range of values using one paint color and basic brush-handling skills. Your arsenal of information will grow with each project, giving you the confidence to move forward with your own creative spirit.

combining techniques

Peaceful Autumn was painted with only one color (Burnt Sienna). This painting is an example of all the methods and techniques used in this chapter's project. Soft edges of color, a variety of textures and thoughtfully placed strokes of paint combine to create a pleasing composition.

● *Peaceful Autumn*
11" × 15" (28cm × 38cm)
Watercolor on 140-lb. (300gsm) cold-pressed watercolor paper
Collection of the artist

Great ability develops and reveals itself increasingly with every new assignment.

—Baltasar Gracian

concepts & materials

about value

Value is the lightness or darkness of a particular color. You can dilute a water-color pigment to create a very thin, pale value or mix the pigment with less water for a concentrated, darker value of the same color.

With watercolor, the white of the paper is always the lightest value. Every paint color has a light, middle and dark value. Lighter colors are referred to as high-key colors or tints. Darker colors are referred to as low-key colors or shades.

granulating pigments

Pigments made from ground minerals create a granulated texture. The heavy particles of pigment lodged in the pockets of paper, making it difficult to lift them away later. Manganese Blue, Cobalt Violet Deep, Ultramarine Violet, Ultramarine Blue and Burnt Sienna are some common granulating pigments.

about brushes

Brushes are essential to painting, and I've experimented with a variety of them over the years. I began using costly sable brushes while in college. I quickly learned that synthetic brushes are economical and last longer, and the fibers of the brush spring back into place to a fine point. They give me the control I need for the way I paint.

materials list

SURFACE
140-lb. (300gsm) cold-pressed water-color paper

BRUSHES
1-inch (25mm) flat
no. 8 round

COLOR
Ultramarine Blue Deep

ADDITIONAL MATERIALS
2B pencil, palette knife, paper towels

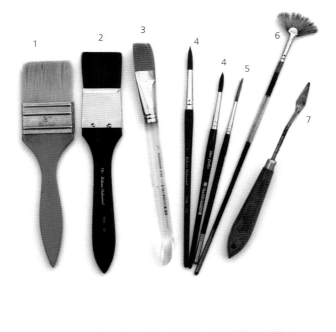

tools of the trade

1 2-inch (51mm) flat by Dynasty Brush Co. This brush holds lots of pigment and creates smooth washes and sharp edges because of the fine-chiseled fibers.

2 1½-inch (38mm) 7010 Quiller Flat by the Jack Richeson Co. This hi-tech brush creates great wash areas as well as thin lines because of its razor sharpness.

3 1-inch (25mm) flat aquarelle. This brush works double-duty as a wash brush for smaller paintings, can cut lines of color through paint, and is the best brush to lift out color.

4 No. 6 and 8 Quiller Round 7000 Series by Jack Richeson Co. These brushes gently release pigment rather than flood pig-ment onto the paper. Each brush can vary from producing a bold stroke to a fine-point line of color.

5 No. 2 synthetic rigger. A rigger is similar to a standard round brush, but the fibers are longer and hold more pigment, which makes this brush handy for creating branches, grasses, telephone wires or rigging on a sailboat.

6 No. 6. Chelveston Pure Bristle Fan Brush by Jack Richeson. This fan brush creates beautiful grasses, evergreen trees and foliage with the flick of a wrist. The harder bristles help me create irregular strokes.

7 Palette knife. I use the palette knife to apply masking fluid and paint, as well as to scrape out color for texture.

value scale in blue

I always tell my students, "If you save some white and push the darks, the midrange values will take care of themselves."

creating value changes

This project's creative challenge is to capture the sun-dappled quality of a crisp winter day. From the smooth, gradated sky and the textured tree line, to the more detailed foreground, your painting will glow with a variety of brushstrokes and value changes.

This project will teach you techniques you'll need for any watercolor painting. Using one color, Ultramarine Blue Deep, you'll learn how to work wet paint onto a wet surface ("wet-into-wet") and how to paint color onto a dry surface ("wet-into-dry"). You will use simple perspective techniques to show distance in the landscape, and push the amount of pigment you use to create value changes for an interesting composition. You'll also learn how to depict texture using a dry-brush method and force a burst of water into drying paint to create a soft-edge tree line.

I'm using Ultramarine Blue Deep for this project because it's a heavily saturated pigment that can be thinned for sheer values or applied thick for dark, rich values. It's a non-staining, granular pigment that allows you to create extra texture effortlessly.

draw the horizon line

Begin by drawing a curvy line on your paper to represent where the snow area meets the tree line in the background.

paint the sky

Use the wet-into-wet technique described in the mini demonstration below. Apply an even wash of clear water above the pencil line. Apply Ultramarine Blue Deep starting at the top of the paper and move down to the pencil line.

mini demonstration

wet-into-wet

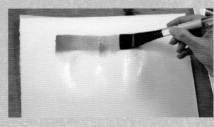

1 Moisten the paper evenly with water. With the 1-inch (25mm) aquarelle flat brush loaded with a medium value of paint, quickly stroke horizontally across the top of the paper and work your way down the page.

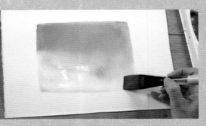

2 The paint will thin as you continue to move down the page, creating a graded wash. The paint will be darker in value at the top and lighter in value at the bottom. It will dry 20 to 30 percent lighter than it is when wet because the paint is being diluted as it combines with the water on the surface of the paper.

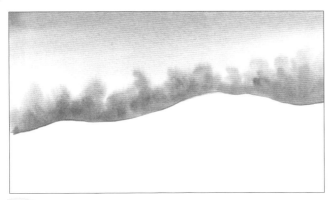

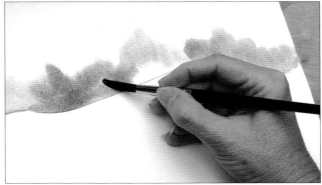

create the tree line
After the sky has dried a bit, add paint just above the pencil line using the no. 8 round brush. The paint should be darker in value than your gradated sky area. This represents a tree line in the background.

force a burst of water
Let the tree line paint dry a bit before adding clean water, forcing a burst into the tree line area with the no. 8 round brush. The clean water will gently move the paint to the drying edge, creating an interesting frilly border for the tree line.

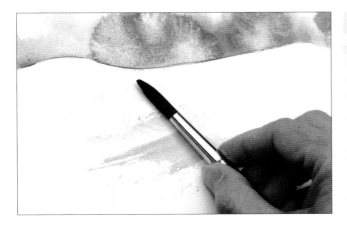

drybrush the foreground
Contour the land covered by snow by using the dry-brush method. To do this, hold a no. 8 round brush perpendicular to the paper and gently skim the brush over the texture of the paper. To achieve this texture, don't overload your brush. The paper should be dry. The deeper crevasses of the paper will remain white while the paint adheres to the top texture of the paper. This method adds a unique texture to the painting and suggests a shadow across the foreground.

mini demonstration
wet-into-dry

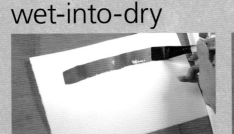

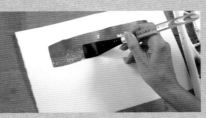

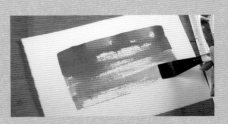

1 Load the 1-inch (25mm) flat brush with pigment and apply it to the dry surface of the paper while holding it flat to the paper. Notice the hard edges that are created by painting onto a dry surface

2 Hold the brush perpendicular to the paper and gently skim it over the texture of the paper. The deeper crevasses of the paper will remain white while the paint adheres to the top texture of the paper.

3 With less pigment to flow from the brush, more texture is created on the dry surface.

forcing a burst

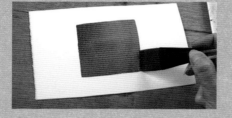 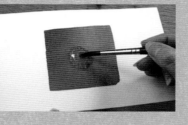

1 Apply color with the 1-inch (25mm) flat. Let the paint dry a bit until the sheen of wetness is gone.

2 Apply clean water using a no. 8 round brush. The water microscopically raises the surface of the paper, forcing the paint to float down the raised area and deposit along the drying edge.

3 A frilly, organic-looking edge is created.

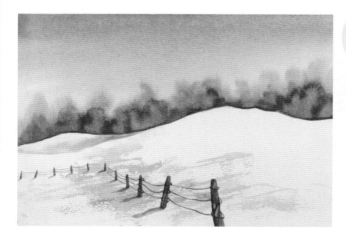

add the fence posts

Make sure your dry-brushed area is dry before you paint the fence posts. The posts are larger and darker in value closer to the foreground, and get smaller and lighter in value as they move into the distance. Add the thin wire fencing using the tip of your no. 8 round. Before the fence posts dry, scrape out some color on the sunny side using your palette knife to create texture and a light area. Use a thinner value of paint and the no. 8 round to cast a shadow onto the snow following the curve of the land.

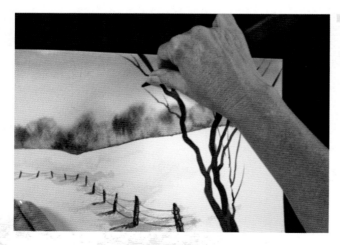

add branches with the palette knife

Applying paint from a palette knife creates natural-looking texture for tree trunks, branches and twigs. You can always scrape the paint away for added texture. Load the back of your palette knife with heavily saturated pigment and paint the main tree trunk. Always work from the bottom up so the ends of the branches thin out in size and value. Continue to fill out the tree, crossing over strokes until it looks full and complete.

Demonstration continues on page 16.

using a palette knife

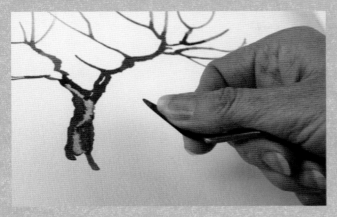

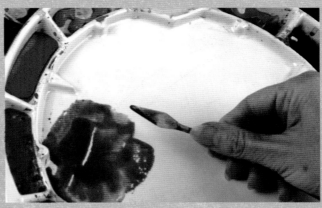

1 Hold the palette knife with your thumb on top and your index finger underneath. Apply pressure to the tip of the palette knife to control the direction of the paint.

2 Using a no. 8 round, premix the color needed by diluting it with fresh water. Scoop up paint on the underside of the palette knife.

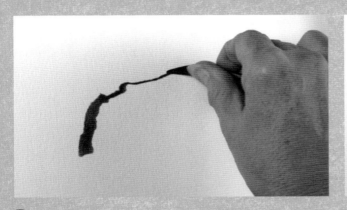

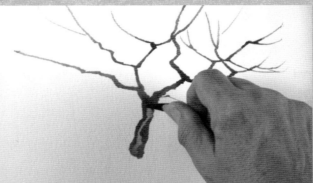

3 Apply the paint as if you were frosting cupcakes, letting the pigment flow off the tip of the knife.

4 Use the palette knife to take away paint as needed. Simply scrape up paint to create texture.

5 The entire tree and grass area was painted using the palette knife. Applying color from a palette knife creates branches and other textures found in nature.

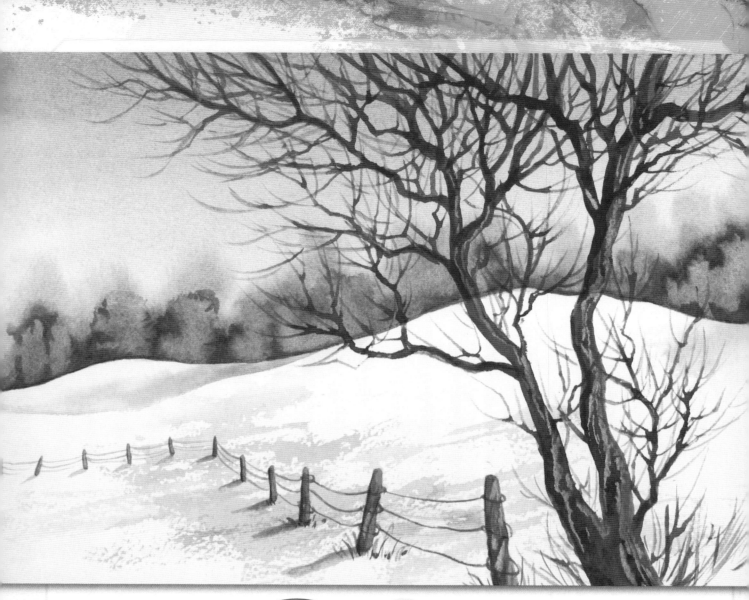

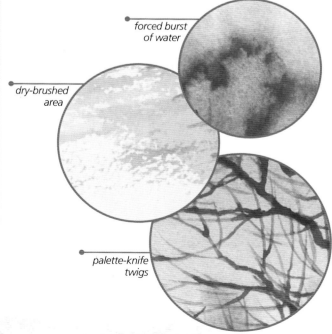

forced burst of water

dry-brushed area

palette-knife twigs

add final details

While the trunk is still wet, scrape out some of the paint to create a more textured effect. Paint in some grasses next to several fence posts with the palette knife and a no. 8 round brush.

The finished painting should depict different surface qualities. There should be quiet places, such as the sky, balanced with textured areas for interest. The value changes create the spatial changes found in nature, so the color should be lighter and diffused in the background, with saturated, rich pigment and detailed subjects in the foreground.

● ***Wisconsin Winter***
Watercolor on 140-lb. (300gsm) cold-pressed watercolor paper
8" × 11" (20cm × 28cm)
Collection of the artist

re-surfacing your techniques
basic brushwork on clayboard

By simply changing your surface, you can drastically change a technique. Many new surfaces are becoming available for watercolorists, and the textures they can provide are wonderfully diverse. Throughout the book, you'll find exercises that illustrate how using the same techniques can express a different side of you on a new surface.

Clayboard is one such surface. With the help of Charles Ewing, Ampersand has developed several types of boards, all archival and acid-free. Aquabord Textured is a clay-coated hardboard that gives watercolorists the ability to create loose washes as well as controlled detail. The paint stays vibrant yet can be layered and reworked easily. There's no need for glass if a protective coating of acrylic varnish is applied.

working wet-into-wet
Even though Clayboard is very absorbent, you can still work wet-into-wet. You'll need to work fast since the water will absorb on the surface quickly. You can achieve soft edges using this approach.

adding paint to a dry surface
The wet-into-dry method can be used to add dark, rich colors and texture. The edges will stay sharp and won't bleed into unwanted areas. Color can also be dabbed on to build up areas of texture. The dabs of color can be large or small strokes.

lifting color
After paint has dried, you can lift it out to either return to the white of the surface or to create a variation of values. Use a thirsty brush to take paint away in various shapes.

endless options
Notice the sharp contrast and definition of color. I enjoy the possibility of taking away unwanted color at any point in the painting process. With Clayboard you can add highlights even at the completion stage of the painting. Finish by applying three coats of an acrylic spray varnish.

● *Hollyhocks*
Watercolor on Ampersand Clayboard Textured
6" × 6" (15cm × 15cm)
Collection of the artist

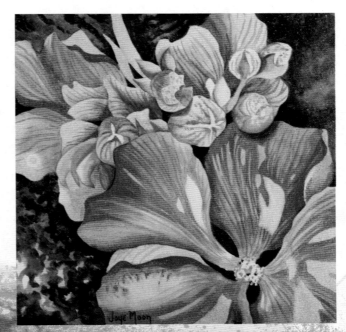

working on the spot

The French call it painting *en plein air*. It's a fancy way to say painting outdoors. Painting on location is more than just capturing what we see with paint on paper. The sights, sounds and smells we encounter in nature can enrich our painting experience and transform us personally and artistically. Once you start painting outdoors, you'll be hooked for life.

After painting outdoors for years, I realized it not only made my artwork stronger, it also brought a sense of peace and solitude to my work as well as to my soul. I observe the landscape with fresh eyes each time I work outdoors. I begin a painting much looser than when working in my studio. I look deeper into the subject and draw colors from nature. I use cast shadows as integral design elements for the composition.

After leading over thirteen international painting tours, I've learned that artists have different comfort levels when painting outdoors. Some need to stand at an easel; others need a chair or a stool. Some artists are content to sit on a stairway while balancing their watercolor paper block on their lap.

I try to sketch the scene before I paint and sometimes take a photograph for later reference. Because there usually are so many great subjects to paint at one location, I might work on several paintings partially and finish them later in the studio. Other times, I'm so enthralled with the location that I keep working on one painting until I'm satisfied with the final results. There are no set rules for painting outdoors, but I've provided a few handy tips to enhance your painting experience.

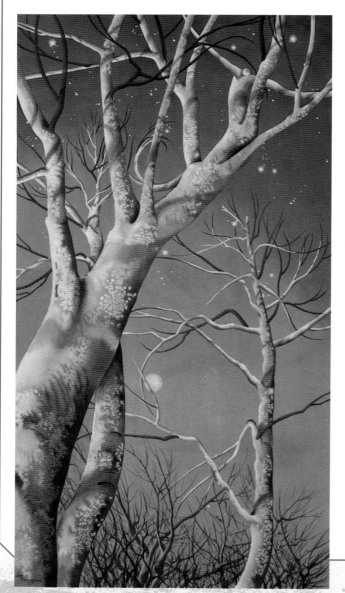

painting in nature's cathedral

As golden aspens quiver against the azure sky
A bird sacredly soars
while thoughts of the past go drifting by

It's not asking enough to just capture the scene
One tries to share the emotion
as if in a dream

Sounds of rushing water gently splashing on rock
This all-encompassing experience
my heart will forever lock

—Joye Moon

● *Under the Aspens*
 Watercolor and casein on 140-lb. (300gsm) cold-pressed watercolor paper
 30" × 18" (76cm × 46cm)
 Collection of the artist

If we did all the things we are capable of doing, we would literally astonish ourselves.

—Thomas Edison

do you want to travel like this?

Easel, multiple sizes of watercolor paper, camera, binoculars, first aid kit, hat, sunglasses, hiking boots, lunch cooler, stool, backpack filled with everything from bug spray to sunscreen to toilet paper, a jacket in a pouch, flashlight, bag with supplies such as paint tubes, every brush you own, watercolor postcards, scissors, masking tape, palette, paper towels and even some lip gloss. Let's face it: your entire studio is in that bag!

or like this?

I'm pretty easygoing. My main goal is to travel light and comfortable, yet with enough equipment to get the job done efficiently. One Magic Bag with key supplies (see below) can get the job done. The hiking boots are replaced with light-weight walking shoes. I also prefer to wear a visor rather then a hat—hats can get too hot.

inside the magic bag

My bag is lined with plastic, which is a nice bonus. I use a travel palette with twenty-four wells filled with watercolor paint, no. 6 round, no. 8 round, 1-inch (25mm) flat, small no. 2 pencil, kneaded eraser, pencil sharpener, black Nexus pen, small scissors, masking tape, collapsible water container, water bottle, two blocks of watercolor paper—one 11" × 15" (28cm × 38cm) and one 9" × 12" (23cm × 30cm), and a few paper towels. All together, this weighs less than 3 pounds (1kg) and includes everything you'll need to paint outdoors efficiently.

exploring
geometric shapes
and color theory

Exploring watercolor through abstraction is a fun and creative exercise. You can set aside any preconceived ideas of what a watercolor should be and simply enjoy playing with paint. Let the unpredictable happen as you build your painting skills.

abstract landscape
This fanciful landscape uses the technique described in this chapter. I first drew the simple tree shapes onto the paper. I continued drawing lines that overlapped the trees. Leaving the tree shapes white brings them forward in the composition. The darker color shapes become the background behind the trees.

● *Fantasy Forest*
Watercolor on 140-lb. (300gsm) cold-pressed watercolor paper
11" × 15" (28cm × 38cm)
Collection of the artist

The sun will never rise or set without my notice and thanks.

—Winslow Homer

concepts & materials

primary, secondary and tertiary colors

Primary colors are red, yellow and blue. Although there are several reds, yellow and blues to choose from, as primary colors, they cannot be made from any other colors.

Secondary colors (orange, violet and green) are created by mixing two primary colors. Mixing red with yellow creates orange. Combining red and blue creates violet, and yellow and blue together create green. Although these colors can be mixed, a variety of secondary colors can be purchased premixed in tube or pan form.

Tertiary colors are made by mixing a primary color with a secondary color to achieve even more color variations.

color wheel

Color wheels are usually organized by a circular chart that shows how primary, secondary and tertiary colors are visibly related. When teaching color theory, I like to keep things simple with what I call the "perfect twelve." These twelve major colors make up the color wheel with three primary colors, three secondary colors and six tertiary colors.

fill your palette

I prefer a palette with deep wells that can hold an abundance of color. I find the color stays in place better when wet. I use a palette that has twelve paint wells in the middle with three additional wells at each corner for extra color.

I set up my color palette just like a color wheel. The "perfect twelve" fill the twelve inside wells, with Primary Yellow at the top moving counterclockwise around the circle. The twelve additional outside wells can hold the "extended palette" colors.

materials list

SURFACE
140-lb. (300gsm) cold-pressed watercolor paper, 11" × 15" (28cm × 38cm) or a quarter sheet

BRUSHES
nos. 6 and 8 rounds

COLORS
Cerulean Blue, Green Blue, Idanthrene Blue, Magenta, Naples Yellow, Permanent Green Light, Permanent Orange, Primary Blue, Primary Yellow, Quinacridone Gold, Rose Madder Deep, Sandal Red, Tiziano Red, Ultramarine Blue

ADDITIONAL MATERIALS
no. 2 pencil, round shapes to trace such as small plates and coffee cups, ruler, kneaded eraser, paper towels

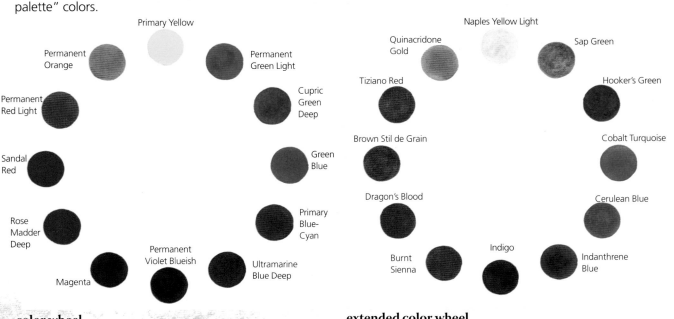

color wheel
When buying paint colors, you'll find there are a variety of primary, secondary and tertiary colors to choose from.

extended color wheel
This is my extended palette of colors. When I need a different color, such as Cobalt Blue, I squirt the new paint color onto a plate or old palette.

staying inside the lines

This fun, abstract painting uses geometric shapes and allows you to experiment with every color on your palette. Volume will appear inside shapes by allowing different colors of paint to commingle in a wet-into-wet area. Gaining knowledge of color and control will enhance your future paintings.

　　Learning to control small wet-into-wet shapes while creating volume and sparkle will enhance your overall brush-handling skills. You'll paint one color into some shapes and blend primary colors into secondary colors in others. Patience is a virtue when it comes to watercolor. Allow each shape to dry completely before painting an adjacent shape, and slow down your brushstrokes to create clean, sharp edges for each geometric shape.

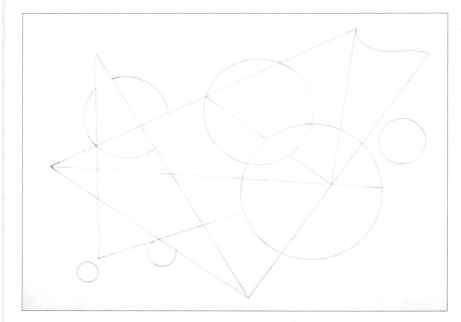

draw on abstract shapes

Draw a variety of shapes using your ruler and round templates (small plates and cups work well). Overlap the shapes to break up the composition. You can freehand some curved lines if desired.

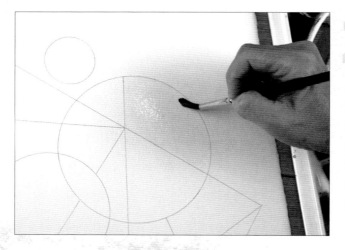

applying water to shapes

Begin by evenly filling in one shape with clear water. To create a small wet-into-wet area, fill the center of one shape with clear water and move the water to the pencil line of the shape. This will keep the area evenly wet (rather than wetting the edge first and having it dry by the time the rest of the area gets filled in with water). If the shape is large, use the no. 8 round to paint the area. If the shape is small, use the no. 6 round. Use the right tool for the job!

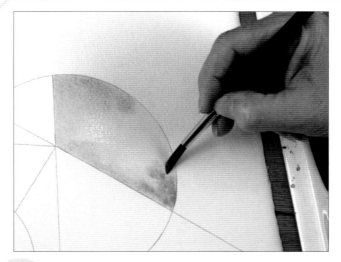

fill in with one color

Before the wet shape dries, paint one color around the inside edge of the shape, allowing the color to wash into the center of the shape. Since you want to depict the illusion of volume, let the paint flow into the center of the shape without completely filling the shape with solid color. Use the same method to paint a few more shapes, making sure to leave dry areas next to shapes you already painted. The first color choices were Permanent Green Light, Cerulean Blue, Tiziano Red, Green Blue and Permanent Orange.

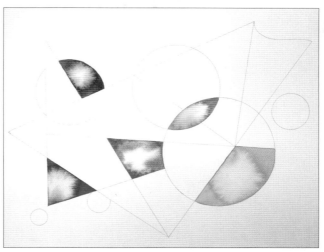

finish the one-color shapes

Notice the painted shapes do not touch. Each shape must have a dry area around it so the color stays inside the shape and doesn't leak into a neighboring shape.

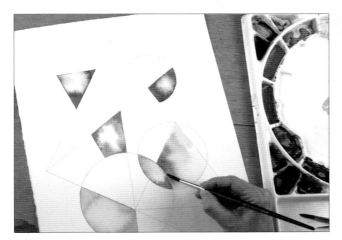

mix primary colors to create secondary colors

When the first shapes are dry, wet other shapes one at a time. Paint the primary colors (e.g. Primary Yellow, Sandal Red and Ultramarine Blue) at the corners of the shapes. The colors will commingle on the wet surface to create secondary colors of greens, violets and oranges.

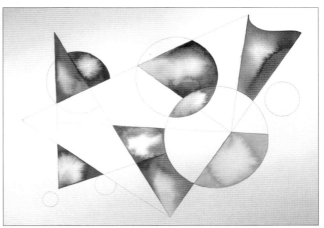

finish the combinations

Notice the interesting secondary colors created from using a variety of reds, yellows and blues. Keep varying your reds, yellows and blues to create different secondary mixtures. You can also use mixtures of Quinacridone Gold, Tiziano Red and Indanthrene Blue, and Naples Yellow, Rose Madder Deep and Primary Blue.

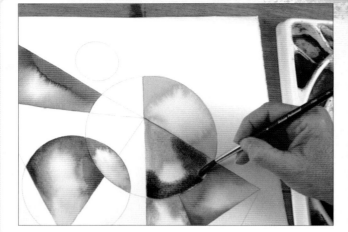

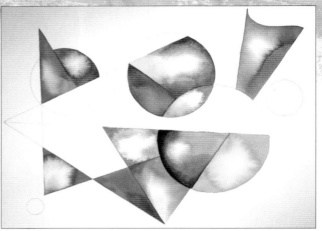

combine complementary colors

Combine true complementary colors to achieve a variety of gray mixtures. Add Permanent Orange to Ultramarine Blue and let commingle. Since these colors are true complements, a varying degree of neutralization will occur inside the wet-into-wet shape.

try other color combinations

Try combining several other complementary colors such as Sandal Red and Green Blue or Magenta and Permanent Green Light.

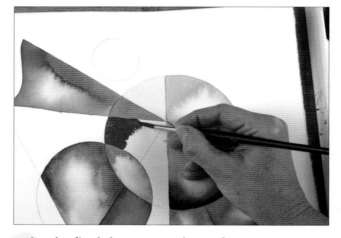

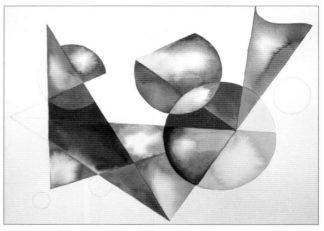

paint the final shapes on a dry surface

Using the color wheel as a reference, you will easily understand analogous colors. Any three consecutive colors next to each other on the color wheel are analogous colors. They are closely related and sometimes referred to as neighboring colors. Pure-hue analogous colors can be altered by mixing the complementary color, creating varying degrees of neutral grays.

Place Vermilion next to Permanent Orange and Primary Yellow to create an analogous color sweep.

finish the solid colors

For variation, paint the last shapes on a dry surface with solid analogous colors. This will create a flat shape. Use the tip of your brush to create tidy edges.

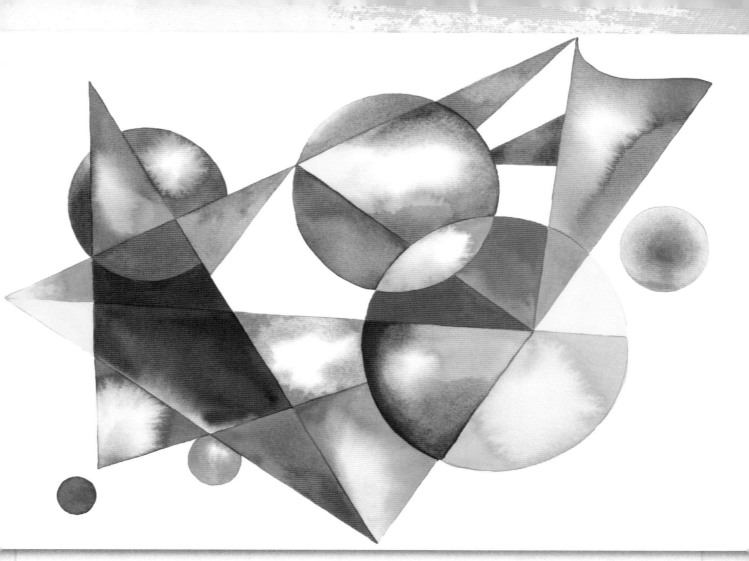

finish painting

Instead of filling in the last few shapes, I decided to leave some white of the paper by dividing the shapes into smaller ones using flat, solid color. With the project completed, think of ways to alter the shapes, and how you can apply these methods in a different format such as a floral or landscape composition.

● *Geometrix*
Watercolor on 140-lb. (300gsm) cold-pressed watercolor paper
11" × 15" (28cm × 38cm)
Collection of the artist

flat color

modeled shapes

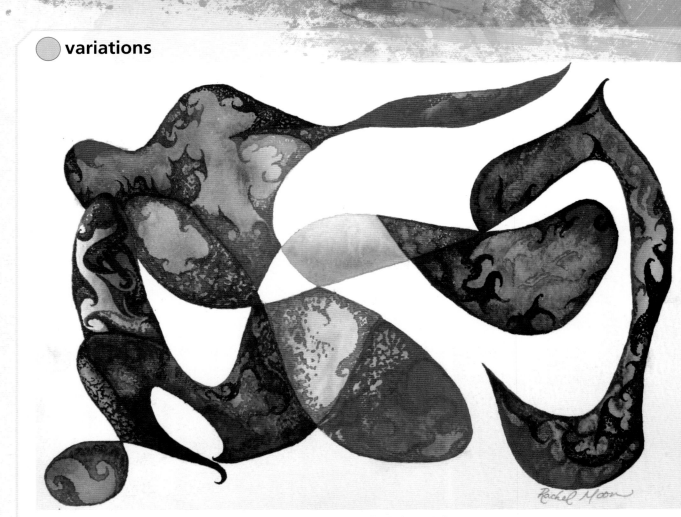

● *Abstraction No. 3*
Rachel Moon
Watercolor on 140-lb. (300gsm) cold-pressed watercolor paper
11" × 15" (28cm × 38cm)
Collection of Joye Moon

shapely stipple

My daughter, Rachel, painted this picture while she was still in grade school. I really enjoyed the curvilinear shapes and the texture she created by stippling the paint to add a design element.

sea of color

The same principles were applied in this fantasy fish composition. Notice how each fish is divided into small, separate areas. I added table salt while some areas were still wet with paint to create texture for more variety. I also forced a burst of clean water to manipulate the color.

● *Fantasy Fish*
Watercolor on 140-lb. (300gsm) cold-pressed watercolor paper
15" × 11" (38cm × 28cm)
Collection of the artist

repainting a scene

Try repainting a familiar scene under different circumstances. One idea always leads to another, at least for me. Sometimes I think I have a good subject idea that needs to be explored more than once. Claude Monet explored this concept by painting a series of wheat stacks at different times of the day in different seasons to explore different lighting effects. His series on the Rouen Cathedral also examines lighting effects that change throughout the day.

In 2001, my travel group stayed in Cassis for a week and fell in love with this charming seaside village. I drew a detailed sketch of Cape Canaille from high above Cassis. During our stay, I viewed many atmospheric changes that I wanted to capture in a completed painting. The painting, *Cassis by Day*, depicts the misty quality of Cape Canaille on a hot, humid Mediterranean day.

The night view of Cape Canaille is amazing since it's always dramatically lit. I thought that working from the same scene, yet depicting it at night, would create a completely different composition. I enjoyed the abstract quality created by the sharp light and dark contrast of Cape Canaille, the Mediterranean Sea and the town of Cassis.

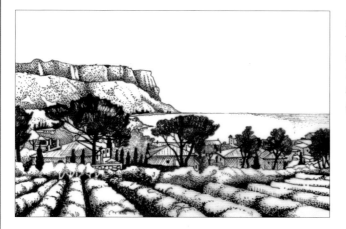

sketch of cape canaille, cassis, france
This sketch of Cassis, France, is from my sketchbook. The sketch includes the lavender fields that are prevalent in this area. The thumbnail sketch is only 4" × 5" (10cm × 13cm).

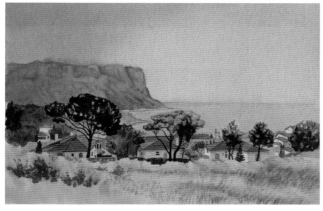

soft and sharp edges
Using the wet-into-wet method, I tried to keep the edges of the mountain range very soft to capture the moist air while portraying the crisp quality of the houses and trees.

● *Cassis by Day*
 Watercolor on 140-lb. (300gsm) cold-pressed watercolor paper
 7" × 11" (18cm × 28cm)
 Collection of William and Margot Castle

nighttime drama
I decided to add a brightly lit building to the scene to create drama in this night landscape.

● *Cassis by Night*
 Watercolor on 140-lb. (300gsm) cold-pressed watercolor paper
 7" × 11" (18cm × 28cm)
 Collection of Rachel Moon

landscape
with a twist

A landscape scene doesn't have to be typical. Let's shake it up, mix it up, and twist it up into something fun and different, yet still keep it recognizable. You'll take the landscape subject to a new level by creating a semirealistic landscape. Along the way, you'll experience the freedom and creativity of using nontraditional materials in conjunction with traditional painting techniques.

limited palette creates cool winter scene

Along the Pike River implements all the methods used in this chapter's project. I used masking fluid to save the white of the paper for birch trees and snow scattered throughout the woods and on the tops of rocks. The limited palette creates a soft, cool feeling for the winter scene.

- *Along the Pike River*
Watercolor on 140-lb. (300gsm) cold-pressed watercolor paper
11" × 15" (28cm × 38cm)
Collection of the artist

The creation of a thousand forests is in one acorn.

—Ralph Waldo Emerson

concepts & materials

pigment properties

Colors are categorized as transparent, semitransparent and opaque. Transparent colors allow light to pass through and reflect off the white of the paper, which gives them a sheer and luminous effect. Several layers of transparent color will still be sheer enough to see underlying pencil lines or paint hues. Semitransparent colors let some light through but appear cloudy. Opaque colors look thick and solid and don't allow any light through. These differences are neither good nor bad, right nor wrong. They simply represent an opportunity to experiment with color combinations.

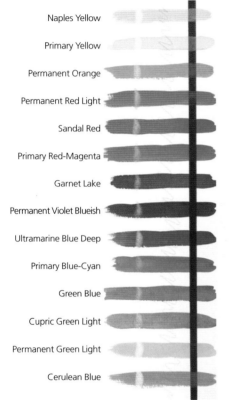

Naples Yellow

Primary Yellow

Permanent Orange

Permanent Red Light

Sandal Red

Primary Red-Magenta

Garnet Lake

Permanent Violet Blueish

Ultramarine Blue Deep

Primary Blue-Cyan

Green Blue

Cupric Green Light

Permanent Green Light

Cerulean Blue

color test chart

To test your paints for their transparent or opaque qualities, paint a stripe of permanent black ink and a pencil scribble. Apply each color over the black ink. You'll easily see which colors are transparent, semitransparent and opaque. Try to lift color to learn which colors are staining or nonstaining.

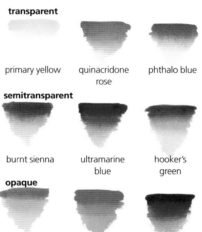

transparent

primary yellow — quinacridone rose — phthalo blue

semitransparent

burnt sienna — ultramarine blue — hooker's green

opaque

yellow ochre — permanent red light — ultramarine violet

materials list

SURFACE
140-lb. (300gsm) cold-pressed watercolor paper

BRUSHES
nos. 6 and 8 rounds

1-inch (25mm) flat

COLORS
Burnt Sienna, Cerulean Blue, Hooker's Green, Naples Yellow, Tiziano Red

ADDITIONAL MATERIALS
surgical gauze, wax paper, plastic wrap, no. 2 pencil, kneaded eraser, paper towels

paint transparency

Manufacturers vary in their claims about pigments being semitransparent and opaque. Always refer to the manufacturer's color charts to learn the exact specifications.

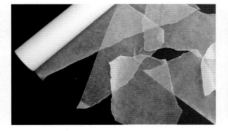

plastic wrap

Tear about 12 inches (30cm) of plastic wrap from the roll. Pull the plastic wrap in different directions to create "happy stretch marks." It should look puckered, not smooth.

wax paper

Tear the wax paper into a variety of sizes. Don't crumple it—it should remain flat to achieve the best contact with the painted surface.

surgical gauze

The surgical gauze I use is eight-ply, so I cut about 4 inches (10cm) from the roll and unfold it. It's important to unfold the gauze; if it's doubled up, it won't transfer the paint efficiently. Manipulate the gauze to make it look more irregular.

creating textures using nontraditional methods

Traditional landscape painting takes on an added twist when you use different methods to create a semirealistic painting. While sitting on my dock over the water, I observed a variety of textures, such as the foliage of the trees, the rocks and the ever-changing movement of the water. Thinking creatively, I considered how I could achieve similar textures without using standard painting methods. I raced to my studio to experiment!

This landscape project explores new ways to create textures found in nature by using plastic wrap to simulate water, wax paper to reflect rocklike textures, and surgical gauze to represent foliage on trees. The landscape elements will seem to paint themselves in the most creative and unexpected ways.

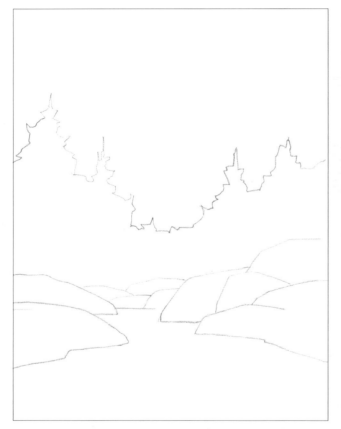

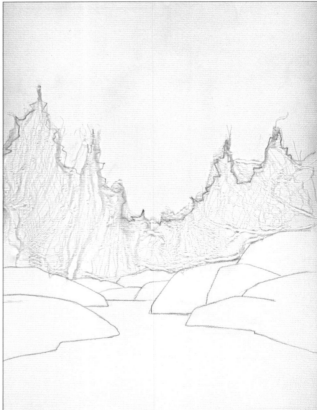

1 draw the basic composition

Draw the simple composition outlines onto watercolor paper. You only need to outline where the foliage ends and where the rock shapes are located. Draw the composition in four sections. Place the sky at the top, the tree foliage area with rocks below, and, finally, the water area.

2 create a wet-into-wet surface

Apply a wash of clear water from the top rock line up into the sky area to create a wet-into-wet surface on the upper part of the paper. A 1-inch (25mm) flat brush will work fine for this. Apply the unfolded and manipulated surgical gauze in the tree foliage area. It doesn't have to fit perfectly. For the best paint transfer, make sure to apply only one layer of gauze.

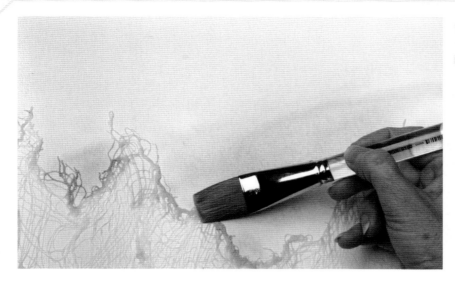

paint the sky
When the surgical gauze is in place, you may need to rewet the top area to make sure it's evenly wet with water. Using a 1-inch (25mm) flat brush, apply Naples Yellow at the top of the sky area and Tiziano Red in the space between the tree foliage. The color value should be lighter at the top and more saturated where the trees meet the sky. The coral color will create either a sunrise or sunset, casting a coral refection on the rocks and water.

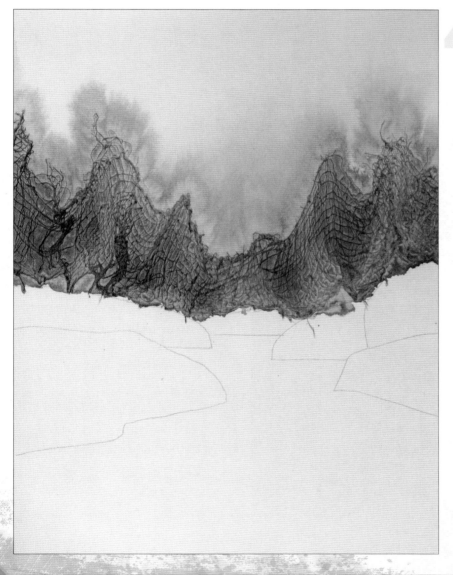

paint the tree area
Load a no. 8 round with Naples Yellow and paint the gauze area. Make sure the paint is heavily saturated (more pigment than water) on the brush. While still wet, apply Cerulean Blue and Hooker's Green to the tree area. Use a bit of Tiziano Red inside the tree area. The Tiziano Red will neutralize the green and create lavenders when combined with the Cerulean Blue, and soft oranges when combined with the Naples Yellow. Since the sky area will still be wet, allow the paint to flow up into the wet area.

Naples Yellow and Cerulean Blue are both opaque pigments. If you apply an opaque pigment using the wet-into-wet method, the colors will dry to a soft, semitransparent veil. I find these two opaque pigments help me achieve a variety of atmospheric qualities. If these pigments are painted over a previously applied color, the result will appear chalky, thick and solid.

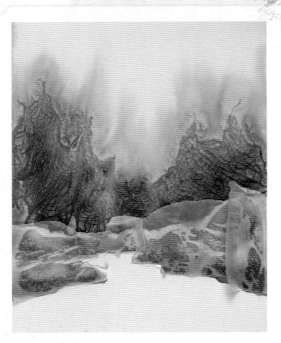

paint the rocks

The rock area should still be dry. Using Burnt Sienna, Cerulean Blue and Tiziano Red, apply thicker paint to this area a portion at a time. You don't have to be fussy when applying the paint to the rock area; the wax paper will mingle the colors and form the textures. Quickly place several wax paper pieces randomly onto the wet, painted surface. If the wax paper doesn't make a wet contact, spray a tiny amount of water under the wax paper. Continue with this process until the rock area is covered with paint and wax paper.

Wax paper has a design formed by the wax that runs parallel to the side edges. Therefore, if you're painting a tall cliff, you will place the wax paper vertically to create vertical textures. If you are painting a rock fence or a stone walkway, you will turn the wax paper horizontally to create horizontal textures.

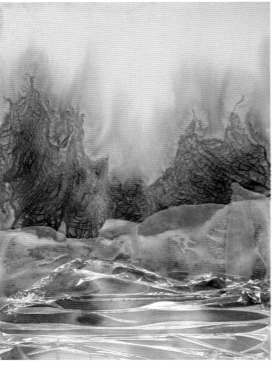

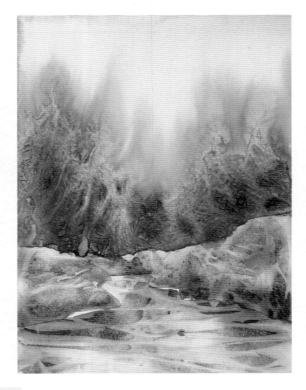

paint the water area

Using a 1-inch (25mm) flat, wet the water area, then apply Tiziano Red, Burnt Sienna, Cerulean Blue and Hooker's Green to create reflections in the water from the rock, trees and sky. While this area is still wet with paint, place your "happy stretch mark" plastic wrap in the water area. Move the plastic wrap until you get a pleasing design in the water. The paint will be lighter where the plastic wrap is raised and darker where it makes contact.

remove the transferring tools

When the watercolor paper is completely dry, remove the plastic wrap, surgical gauze and wax paper. Notice the interesting textures created by using different substances, and how the paint colors mingled to make interesting secondary colors.

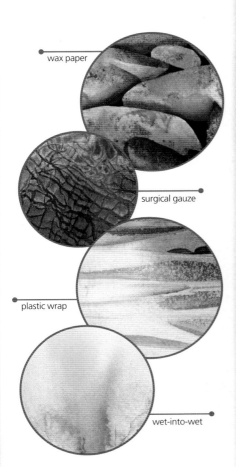

wax paper

surgical gauze

plastic wrap

wet-into-wet

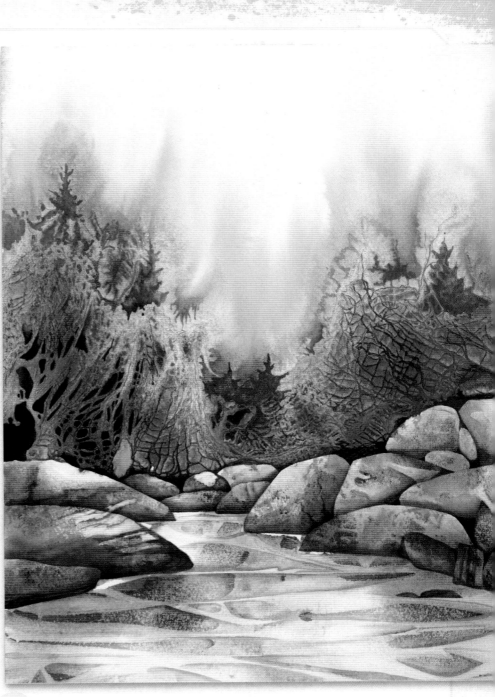

add the finishing touches

Finish the painting by emphasizing various textures such as the frilly edge around the tree area. You can also add new trees such as evergreens poking out from the background. Use some of the gauze texture for the trees by painting the background behind them. Use the textures in the rock area to form the rock shapes. To separate the rock shapes, paint the rock behind a front rock a bit darker where the two meet. Enhance the design in the water area by painting some of the ripples darker for contrast.

● *Up North*
15" × 11" (38cm × 28cm)
Watercolor on 140-lb. (300gsm) cold-pressed watercolor paper
Collection of the artist

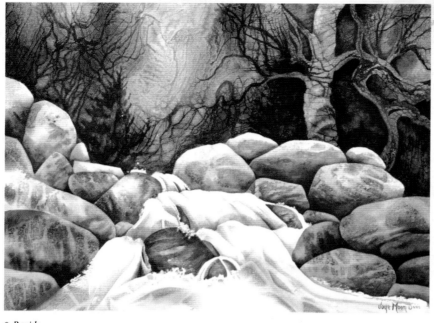

textural landscape

You can see how the surgical gauze was used to cover the top of this painting. The overall surgical gauze texture acts as the tree foliage area. I discovered a big tree trunk in the gauze area and decided to paint the background darker to pop the tree forward in the scene. I also lifted some color out of the tree trunk for an added value change. I applied the plastic wrap in a downward direction to simulate the falling water of the rapids. I used a razor blade to scrape out color to regain the white of the paper for foam on the running water. Just a little extra painting completed this composition filled with textures found in nature.

● *Rapids*
 Watercolor on 140-lb. (300gsm) cold-pressed watercolor paper
 11" × 15" (28cm × 38cm)
 Private collection

grapes on gessobord

Though *Grape Harvest* uses surgical gauze texture in the background and wax paper for the grape shapes, it takes the idea a bit further. I used actual grape leaves to create the leaf texture. I pressed them into position while the paint was still quite wet. The veining of the leaves transferred onto the smooth gesso surface.

● *Grape Harvest*
 Watercolor and ink on Gessobord by Ampersand
 10" × 8" (25cm × 20cm)
 Collection of the artist

painting the emotional landscape

How could you not enjoy a thermos of hot chocolate while painting in a farmer's field as a buck chases a doe right in front of your eyes? Or painting while sitting outside a bakery in a tiny Italian village, watching people walk by with their market bags filled with fresh produce? The sounds, smells, hustle and bustle of the day or the tranquility of a tinkling stream enrich the painting experience as well as your life. Once you've experienced and then painted a scene, it's locked in your memory forever.

I think of master painters I admire and wonder if they have walked these very paths along the Maine coast or sat in the same spot to paint their famous scenes. This thought inspires me tremendously.

Because I'm not trying to record the scene as if in a photograph, I can play with the color scheme to heighten the feeling it gives me. Or I can add sunshine and shadow to a gray day because my mood is sunny. I might forego the texture in a grassy area and decide to paint a smooth pathway to lead the viewer into the composition. So, before you begin, consider what you want to convey with your painting and how you want your audience to feel while viewing your work.

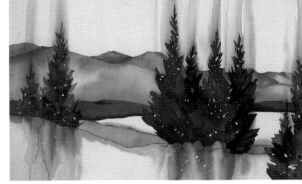

spectacular mountains

The mountains ouside Pagosa Springs, Colorado, are simply spectacular and fun to incorporate into paintings. This poured project implemented a limited palette of color. I left a greate deal of white paper to create a nice glow on the snow areas.

- *Winter Landscape*
 Watercolor on 140-lb. (300gsm) cold-pressed watercolor paper
 15" × 22" (38cm × 56cm)
 Collection of the artist

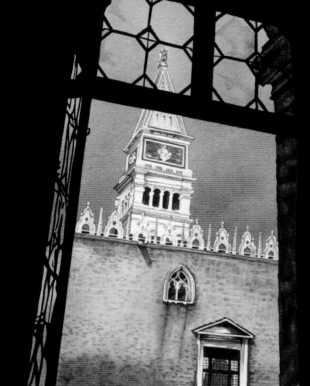

palatial view

While touring the Doge's Palace in Venice, Italy, the graphic view from the window caught my attention. The sky was actually a beautiful Cerulean Blue but the air was so hot and humid that I had to interpret the day with a hot coral sky.

- *Out the Doge's Window*
 Watercolor on 140-lb. (300gsm) cold-pressed watercolor paper
 11" × 8" (28cm × 20cm)
 Collection of the artist

turning a negative
into a positive

We see in positive images and sometimes never notice the space
around or behind an object. Seeing beyond the positive image
was the hardest creative challenge I ever experienced but was
extremely important to my artistic development. I actually drew
the positive image and only painted the background over and over
again using all sorts of subject matter. From flowers and rocks to
cups and baskets, I focused on seeing the negative space around
the object. Once I could creatively visualize my positive shape, I was
able to create the negative shape with ease. You will be challenged
by this next project, but the artistic rewards will be great!

from snapshot to painting
I took a photo of these trumpet flow-
ers that were growing just outside the
doorway of Renoir's home in the south of
France. I used the snapshot as my idea-
starter. I tried to capture the warm, soft
quality of the day in this painting.

● *Trumpet Blossoms*
Watercolor on 140-lb. (300gsm) cold-pressed
watercolor paper
11" × 15" (28cm × 38cm)
Collection of the artist

*I have no special talents. I am only
passionately curious.*
—Albert Einstein

concepts & materials

pen and ink

There are many types of pens that work well on watercolor paper. Use pens that are 100 percent archival, meaning pH neutral and acid-free. The ink should also be lightfast and waterproof. Markers have nylon tips, brush tips and calligraphy tips of various sizes. Other pens (e.g. ballpoint pens) have roller tips and usually only one size point.

positive and negative space

Negative painting is simply painting the area behind or around the object instead of painting the object itself. Paint or draw the background behind the object. The space behind the object becomes the negative space and you're left with the positive shape or the object. The benefit of looking for positive and negative shapes is that it will help you draw and paint more accurately. Instead of drawing your idea of a flower, you'll draw what you actually see. Negatives can also help you determine the spatial relationships between objects more accurately.

positive flower, negative flower
The first flower image is a positive shape. Notice the stem, leaves and blossoms are painted with color. In the second image, only the background is painted. The same flower is depicted, yet it's created by painting around and behind the image of the flower.

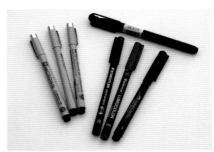

pens and markers
Here is a sampling of the pens and markers available.

1. Micron pens by Sakura are available in various sizes and colors and are waterproof, archival and fade proof. These pens are great for any type of sketching of fine detailed drawings.

2. Nexus pens by Koh-I-Noor have a roller tip and are waterproof and archival fade proof. They are available in a variety of colors but just one size. They work great over collage papers.

3. Faber-Castell pens come with a brush nib suitable for drawing, lettering and illustrations. They are archival and fade proof and are available in a variety of colors.

4. Staedtler pens are available in many colors and an array of tip sizes. They are archival and fade proof.

mini demonstration

drawing negative shapes

1 Here's a simple tulip shape. A thin, light color was painted into the background area behind the flower shape and left to dry.

2 Another tulip shape has been drawn into the background. The second flower was created by painting a darker value of the same color over the background, painting around both flower shapes, and leaving it to dry.

3 Finally, the last tulips were drawn into the background color created in step 2. A darker value of paint was applied to the tiny bits of remaining background. Each phase of color moves the tulips back in space.

negative painting using stencils

This project has helped many students quickly understand the negative painting process. You'll transition from using simple stencil shapes into creatively visualizing free-flowing branches of leaves by simply painting the background areas. You'll even get a chance to experiment with various drawing methods as you use an ink pen to complete your composition.

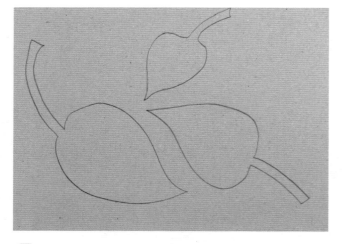

create stencils

Draw a small, medium and large leaf shape onto posterboard. Make sure there is a noticeable size difference with each leaf, but keep the shapes themselves simple—you can alter them with texture later to make them more expressive.

Curiosity will conquer fear even more than bravery will.

—James Stephens

draw leaf shapes on paper

Arrange and rearrange the leaf stencils on watercolor paper until you're satisfied with the pattern. I chose a falling pattern. You may want to overlap two leaves to create an interesting composition with connecting shapes that move the viewer's eye through the painting. Trace the shapes onto the paper with a pencil. Erase the portion of the leaf that is overlapped.

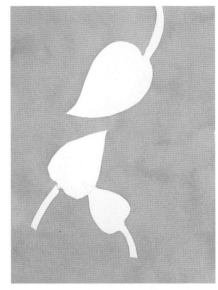

apply color to the first layer of negative space

Using a 1-inch (25mm) flat brush, paint the background with a thin value of Permanent Orange, leaving the leaf shapes the white of the paper. The paint mixture should not be too light or it will be too pale when it dries. Make sure you mix more than enough color to cover the entire background.

apply table salt

While the paint is still wet, apply the table salt carefully where you want texture. This texture will be used for your next leaf shapes. See the mini demonstration below for further instruction on this technique. Let the paint dry.

Demonstration continues on page 40.

mini demonstration

salt texturing

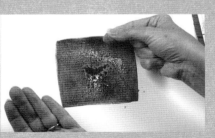

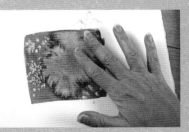

1 Using the 1-inch (25mm) flat, create a wet-into-wet surface with fresh water. Apply some rich (i.e. heavily saturated) color.

2 Apply salt before surface dries. Don't just sprinkle salt all over the paper. Control where you place the salt by putting a small amount in the palm of your hand. Take a pinch of salt with your index finger and thumb, placing the salt where you want the texture to appear.

3 Brush off all remaining salt when the surface is completely dry. The salt crystals create a tiny burst on the drier surface. The larger textural burst forms on the wetter surface.

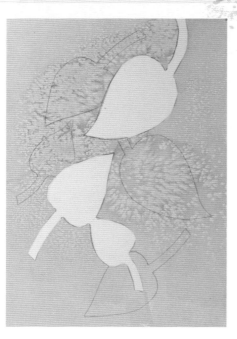

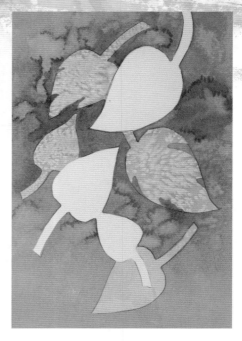

place the second leaf layer

When the first background is dry and you have removed any salt crystals from the paper, trace the three stencils once again onto the composition. Keep in mind the falling leaf pattern you want to convey. Try to position these leaves into the salt texture areas you just created to take advantage of the texture. You can turn your stencils upside down and backwards for variety. When you're satisfied, trace the stencils onto the paper with a pencil.

add the second color layer

Paint only the leftover background using a mixture of Permanent Orange and Permanent Green Light. Because your background area is getting smaller, switch to a no. 8 round brush for this phase. You don't want the value to be too dark, but the mixture should be deeper in value than the first background color. To provide a little creative variety, alter the edges of a few leaves by adding notches, unusual curves or a serrated edge.

After the paint has lost some of its sheen, force random bursts of water (see page 14) into the painted area to create another texture.

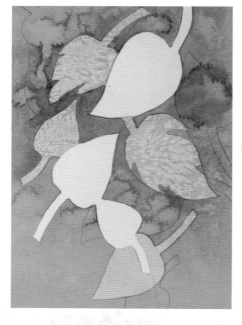

place the final leaf layer

When the second paint mixture dries, trace the final layer of leaves onto the composition. You may need to trace more than three stencils to complete your composition. Use the textures created by the forced bursts of water in your final leaf shapes.

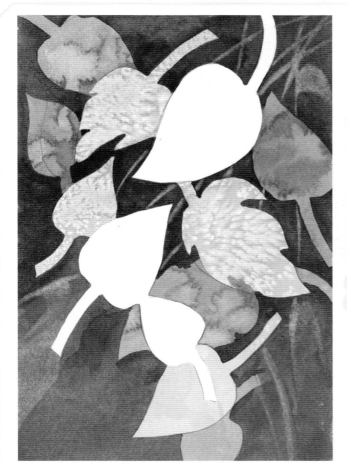

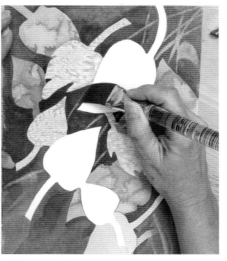

add the final color layer

Continue painting the remaining background using the no. 8 round brush and possibly the no. 6 round for tight areas. Use Dragon's Blood, making sure that the value is darker than in the previous layer. As the paint starts to lose its sheen, use a clean, slightly damp 1-inch (25mm) flat brush to lift color to create twig and leaf shapes. You may need to stroke the brush over the area several times to pick up enough pigment to lighten the value. Just be sure to wipe the pigment from the brush between strokes.

Demonstration continues on page 43

mini demonstration

lifting paint

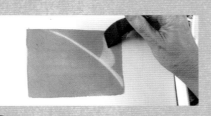

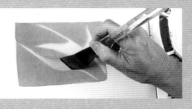

1 Apply rich color to a wet-into-wet area and let it dry a little until the wet sheen starts to dry.

2 Before the paint dries, use the 1-inch (25mm) brush to lift color out in varying designs. Apply more pressure to the brush to pick up a bold color shape. Lift the brush up to use the tip to lift a line of color.

3 Lifted shapes will become positive shapes. Notice how the twig with leaves and the grass shapes commingle in the design.

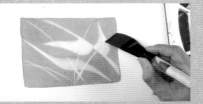

4 Switch directions to overlap the design elements.

working with ink

Combining ink with watercolor can increase the depth of a painting. Crosshatching, stippling and scribbling are drawing methods that can be incorporated into your work. Using an interesting line around an object is equally important in finishing your project.

I find a roller tip pen works well for the finishing touches. I use this pen to tidy up edges and create textures inside the leaf shapes, as well as to emphasize interesting textures and patterns in the background area. Make sure the pen you use is archival and won't fade. It's most important to use quality materials.

scribble
Sometime when I have a large area to fill, I implement the scribble method to get the job done quickly. A variety of values ranging from dark to light can be achieved by building up multiple layers of scribbles.

1 Crosshatched strokes applied close together will appear darker in value than those farther apart.

Start by placing lines in a pattern along the edge of an object. Don't worry about each line not being perfect. There can be some variation.

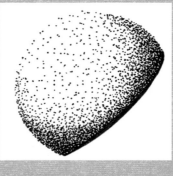

stipple
By stippling, you can create a value change from light to dark by applying more dots. Where the dots are few, the area will appear lighter. Where the dots are close together, the value will be darker. This can create the rounding of a leaf or depth in the background.

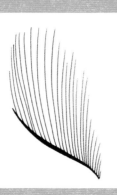

2 Cross over with a second layer of strokes in a different direction to build up the pattern and create an even darker value.

changing the line quality
It's more interesting to have the line vary from thin to thick. Since the pen only has one size nib, you can build up the line by passing over a portion of the line several times to vary the thickness.

3 Draw more lines in yet another direction so the lines fill in more space, creating the darkest buildup of lines.

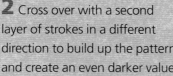

creating form

Just drawing the outer edge of a leaf will create the appearance of a flat leaf. To give a leaf some curve and form, use the stippling method inside the leaf shape to develop the inner stem and veining. Curve the direction of the stem and veins to make the leaf appear as if the leaf is rounded and not flat.

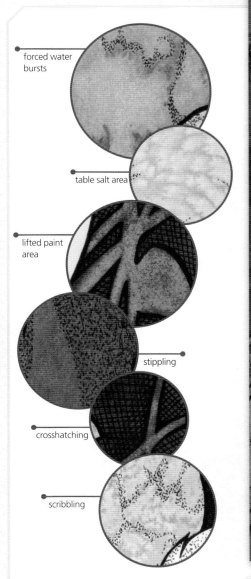

forced water
bursts

table salt area

lifted paint
area

stippling

crosshatching

scribbling

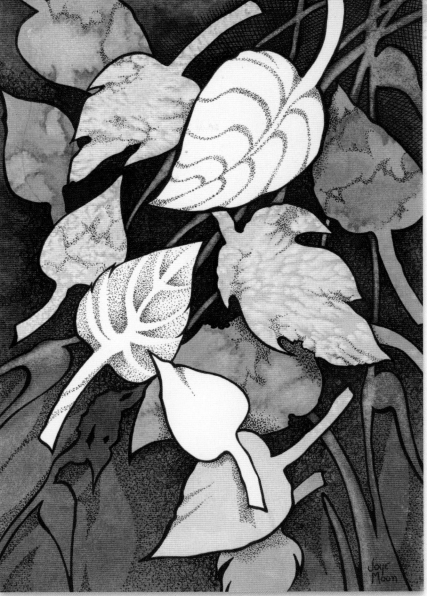

add the final details

Begin by drawing around each leaf shape with an interesting line quality to vary the leaf from its original stencil shape. Use the stippling technique to create veining inside several white leaves and to drop shadows and enhance the design created by the salt.

Evaluate the lifted designs of twigs and leaves, then draw around them to give them more identity in the background.

In my painting, there was still background space that was plain color. I decided to use the stippling technique in the background, or negative space, to develop more positive leaves and stems. I also used crosshatching and scribbling for added depth in the background.

The finished composition is neat and tidy with four distinct values of paint. The various ink textures in the background enhance the composition by creating even more depth with value changes.

● *Falling Leaves*
Watercolor on 140-lb. (300gsm) cold-pressed watercolor paper
11" × 8" (28cm × 20cm)
Collection of the artist

● variations

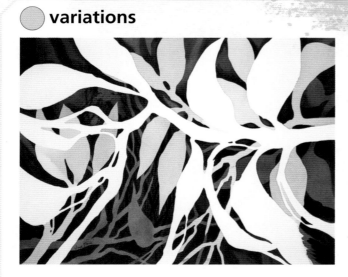

river of white

Now that you've worked with negative space using stencils, try to creatively visualize leaves by painting the background, or negative space, behind groupings of leaves.

This painting has a continuous white shape that begins with a branch and continues into leaves flowing off the twigs. I refer to this as the "river of white." I painted the background, keeping the white shape as my positive image. I continued with two additional layers of the same pigment, deepening the values to complete the painting.

● *Intertwine*
Watercolor and ink on 140-lb. (300gsm) cold-pressed watercolor paper
11" × 15" (28cm × 38cm)
Collection of the artist

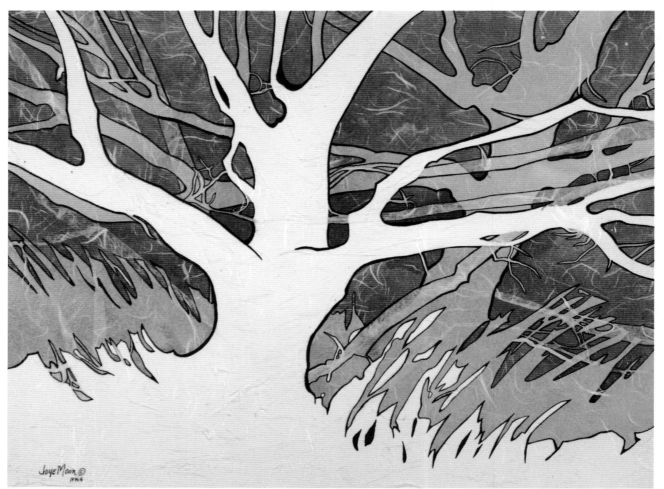

deep in the forest

It might be helpful to transition from the leaf subject to a landscape using trees as your imagery. Begin with a large tree growing out of grassy white land. Continue painting only the background making sure you don't cut off a branch with a wild brushstroke. Once again, you want the flow of white paper to be your main image of the land and tree. Create several more background areas, moving deeper into the forest of trees. Finish by using your pen to define grasses, branches and foliage.

● *Autumn Trees*
Watercolor and ink on 140-lb. (300gsm) cold-pressed watercolor paper and Unryu paper
11" × 15" (28cm × 38cm)
Collection of the artist

stenciling on watercolor canvas

Watercolor canvas is primed with a specially formulated gesso that accepts all water-based paints, including transparent and opaque watercolor, acrylic and watercolor ink and watercolor pencils. It's 100 percent acid-free cotton canvas that comes prestretched on stretcher bars or in canvas rolls. Completed paintings can be sprayed with an archival varnish and displayed without glass.

<div style="border">

featured surface

Fredrix Watercolor canvas

</div>

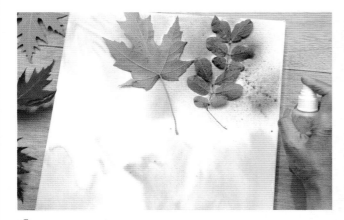

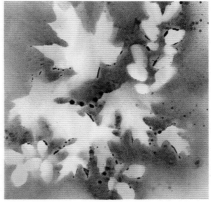

1 *spray with paint*
Paint thin washes of Naples Yellow, Quinacridone Gold, Dragon's Blood and Hooker's Green onto a wet-into-wet surface to achieve soft edges. Mix thicker values of the same colors with water and pour into small spray bottles. After the wet-into-wet surface is dry, position leaves onto the canvas and spray with color. The fresh leaves act as natural stencils.

2 *consider your composition*
Place more leaves onto the surface, keeping your composition in mind. Have some leaves extend beyond the edges of the canvas. Overlapping leaves will connect the shapes and move the viewer's eye through the composition.

To maintain hard edges, spray only onto a dry surface. The texture of the watercolor canvas should be just visible enough to supply an almost crosshatched effect to the entire piece.

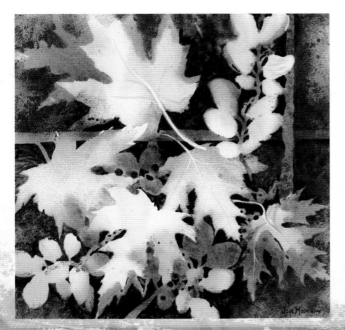

3 *lift color and add another layer*
Since the paint sits on the surface of the canvas, lifting color is easy. Use a thirsty brush to lift away paint to achieve highlights or to get rid of color that's too dark. You can even lift your signature with a fine brush.

After removing the leaves to check the progress, I put them loosely back into place. This creates a ghostly echo effect. Scrape watercolor pencil shavings with sandpaper to vary the color and depth of the background. This surface accepts the watercolor pencil nicely. The crosshatching of the canvas' texture and the loose roundness of the sprayed pigment work well together.

● **Maple Leaves**
 Watercolor and watercolor pencil on Fredrix Archival Watercolor Canvas
 12" × 12" (30cm × 30cm)
 Collection of the artist

pouring your
heart out

Using a brush is the standard way to paint a picture. *Pouring* paint, however, gets you out of your comfort zone and invigorates your senses. The spontaneity of pouring paint from a cup onto a wet or dry surface creates a flow of painterly possibilities. The control you enjoy with a brush is gone, but is replaced by random patterns of fresh, juicy color. I constantly hear workshop participants lamenting how tightly they paint. Pouring paint is the fastest way to loosen up and bring new energy to your work.

combining approaches

Yellow Tulips is a fine example of a poured paint composition. I enjoy the sunlit quality as well as the hard edges created by using masking fluid to save shapes of color. I used conventional painting methods such as softening edges and painting the centers of the flowers for the final touches, giving the tulips a more realistic appearance.

● **Yellow Tulips**
 Watercolor on 140-lb. (300gsm) cold-pressed watercolor paper
 15" × 22" (38cm × 56cm)
 Collection of Jeremy Woodliff

There is a boundary to men's passions when they act from feelings; but none when they are under the influence of imagination.

—Edmund Burke

concepts & materials

pouring
There are many ways to pour paint. Pouring an individual color and letting it dry before adding another color creates a graphic effect, showing each color separately. Pouring another color while the first is still wet creates varied mixtures of color. Either way is fine depending on the look you're trying to achieve.

combining primary colors to create secondary colors
Let's use the primary colors red, yellow and blue as our pouring colors. Combining these three colors creates the secondary colors of orange, violet and green. Since the amount of paint being poured can't be exactly controlled, the resulting secondary colors might not be exact.

combining complementary colors
Complementary colors are located opposite each other on the color wheel. Painted side by side, these colors create a vibrant color scheme. Mixing complementaries creates colorful neutral browns and grays.

masking fluid
Masking fluid is a substance that can be applied to an area—either the white of the paper or an area of previously painted color—to protect it from the additional layers of paint.

materials list

SURFACE
300-lb. (640gsm) cold-pressed watercolor paper

BRUSHES
nos. 6 and 8 rounds
1-inch (25mm) and 2-inch (51mm) flats

COLORS
Burnt Sienna, Cerulean Blue, Hooker's Green, Naples Yellow, Tiziano Red, Quinacridone Gold

ADDITIONAL MATERIALS
masking fluid, palette knife, rubber cement pick-up, small disposable cups, paper towels, large tray for pouring (either a butcher tray or the top of your palette), no. 2 pencil

yellow + red = orange
First pour Primary Yellow and add Rose Madder Deep before the yellow dries. The combination will create orange, a secondary color.

blue + red = violet
First pour Ultramarine Blue and add Rose Madder Deep before the blue dries. The combination will create the secondary color violet.

yellow + blue = green
First pour Primary Yellow and add Ultramarine Blue before the yellow dries. The combination will make the secondary color green.

rubber cement pick-up
When the masking fluid is no longer needed, a rubber cement pick-up can be used to remove the dry masking fluid. At this point, the uncovered paper can be painted or left white.

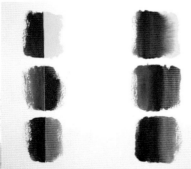

combining complementaries
Placing complementary colors such as red and green, yellow and violet, or blue and orange side by side creates a vibrant color scheme that pops.

Mixing complementary colors creates beautiful neutrals. The more evenly the colors are combined, the truer the neutral.

batik painting

This project will challenge your creative instincts and propel your work into unknown areas. I'm working from a sketch done outside Renoir's home, Les Collettes, in Cagnes-sur-Mer, France. These trumpet-shaped moonflowers were actually white, but I changed their color to add more drama to my composition. I combine brushwork with pouring to partially control the paint. This method bridges the gap between being totally in control (using brushes) and out of control (by pouring paint). I refer to this method as batik painting. The process is similar to fabric batik. You will use paper instead of fabric, paint instead of dye, and masking fluid as the resist instead of melted wax.

Teaming masking fluid with poured paint creates graphic effects with a fluid freedom that can't be achieved with standard brushwork. When buying masking fluid, avoid those that are heavily tinted with pink, blue or gray as they tend to stain the paper. Always make sure it's fresh and never shake the bottle as that adds air bubbles to the product and dries it out faster. Instead, stir the bottle gently with the brush handle before using. You can add a few drops of water to the bottle if it doesn't flow off your brush or palette knife easily. This project is 80 percent preparation and 20 percent painting, but hang in there—the results are worth it.

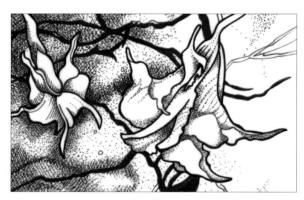

inspiring drawing
This is the sketch I drew at Renoir's home in the south of France. I began with a simple outline on location and filled in the detail later.

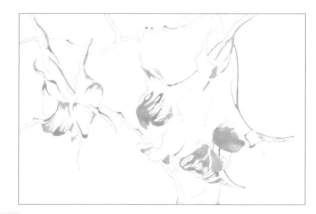

draw the flowers

Draw a simple outline of the flower shapes. Use your pencil to mark the value changes in each flower: Separate the flower into white areas, mid-light areas and darker areas. This will help you know where to save different values with the masking fluid.

mask the white areas

Apply masking fluid to the areas you intend to keep white. You can also randomly splatter masking fluid to save some white sparkles. Allow the masking fluid to dry completely. It will still feel tacky but shouldn't stick to your fingers.

Demonstration continues on page 50.

masking fluid

Artists typically apply masking fluid with a brush, first dipping the brush in liquid soap to protect the bristles, but the end result for me is a dead brush and gloppy-looking areas. I experimented with a variety of tools and found the palette knife to be the most effective. I can apply the masking fluid thickly to cover large areas, or as tiny lines for strands of hair or grasses. The result is no mess and no ruined brush.

You can use other items to create different effects with masking fluid. A toothbrush, natural sponge, toothpick, plastic syringe—these can all be used to achieve interesting textures with masking fluid. If masking fluid goes where you don't want it, or the shape isn't what you were hoping for, wait until it dries and remove it with a rubber cement pick-up. Never remove the masking fluid by rubbing it up with your finger. The oils from your fingers can damage the paper.

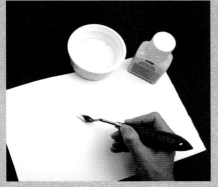

palette knife—fine lines

Using the palette knife as a trowel, let the masking fluid flow off the bottom of the knife. Create fine grasses and twigs by turning the palette knife slightly so the masking fluid flows thinly off the edge. To cover large areas, apply the masking fluid as if you were frosting cupcakes. Be sure to keep the outer edges of a shape tidy.

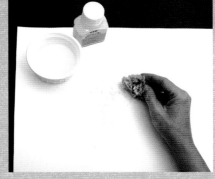

natural sponge

Natural sponges produce interesting foliage, grasses and background areas. Moisten the sponge, then squeeze out any extra water before you dip it into the masking fluid. Apply the masking fluid in clumps for foliage or brush the sponge across the paper for rough grass shapes. Rinse the sponge thoroughly to remove all the masking fluid before it dries.

toothbrush

The toothbrush comes in handy for spraying dots of masking fluid—perfect for the spray from a crashing wave or tiny flowers in the distance. Wet the toothbrush, then tap off most of the water before dipping it into the masking fluid. Flick your thumb backward across the bristles to spray the masking fluid across the paper. Practice on newspaper to get the feel of it. Sometimes I cover portions of my painting with paper towels to prevent the masking fluid from going where I don't want it. Rinse the toothbrush thoroughly before the masking fluid dries. Never leave masking fluid on your painting for more than two months. It can bond with the paper and become impossible to remove.

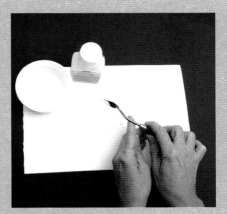

palette knife—splatter

The palette knife works well for creating random splatters of masking fluid. Scoop up the masking fluid with the palette knife and tap it against your other hand to create drops. This method produces larger drops than the toothbrush does. Cover portions of your painting with scrap paper or paper towels to avoid splattering masking fluid where it isn't wanted. Once the masking fluid dries on your palette knife, you can peel it off easily.

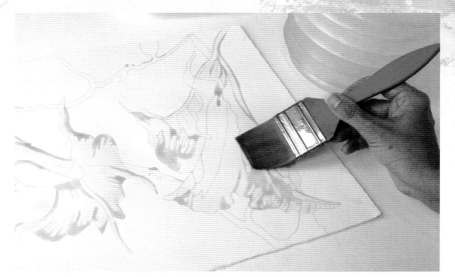

wet the blossoms

Premix water and Tiziano Red in a small cup. The value should be somewhat thin. Test the mixture on scrap paper to make sure you're satisfied with the value. Once this is complete, apply water to the blossoms using a 2-inch (51mm) flat brush.

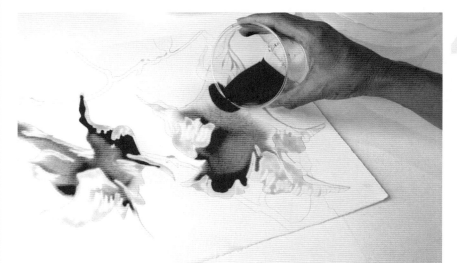

pour the first paint mixtures

Pour the paint mixture into the wet flower blossom area. Lift your paper to tip it into different directions, forcing beads of paint into the background area. These shapes may become twigs later.

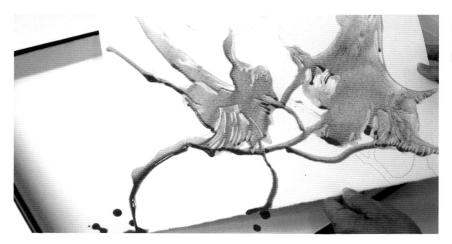

let the paint drip into a pan

Pour your paint over a butcher tray or the top of your palette. Reclaim the paint that runs off your painting by draining it back into your pouring cup.

apply more masking fluid

You've already saved the white of the paper. Now save the next light color value. When the paint dries, apply more masking fluid where you want to save some of the color you just poured. Design interesting areas each time you mask. Consider creating a variety of color shapes. While the masking fluid is drying, create a more heavily saturated paint mixture that will be your second color by adding more Tiziano Red to your cup of paint.

pour more paint

Once again, wet the flower blossom with water and pour your thicker color mixture into the blossom area only. You can tip your paper to create more twiglike runners if you desire. Reclaim the paint and let the painting dry completely.

apply the final masking fluid

Mask one last time, saving some of the last value color you just poured. At this point, the blossom is filling in with only enough space for one last pouring. You may want to save some twig shapes with the masking fluid as well.

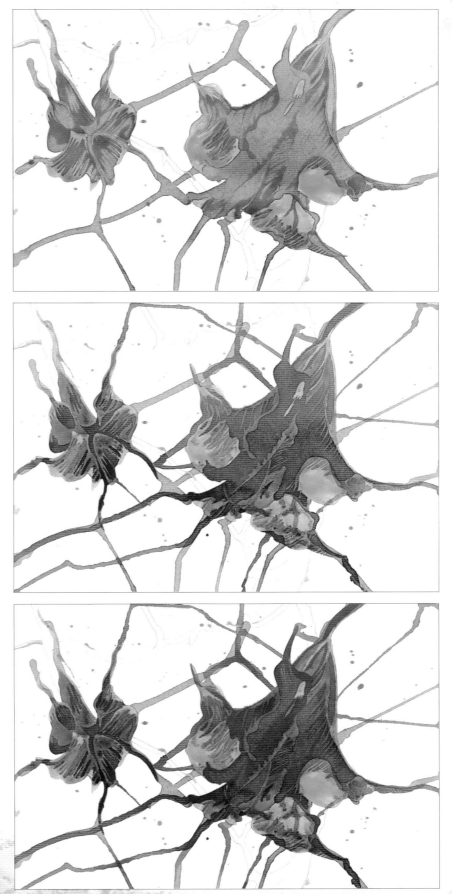

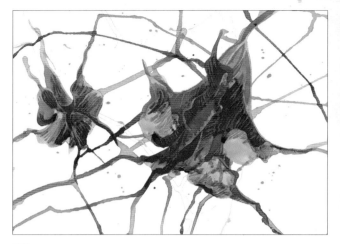

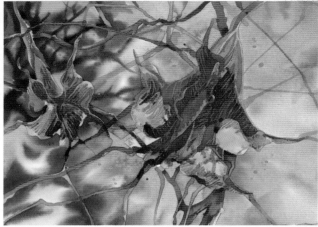

pour the last paint layer

Your last pour will be the darkest value of the flower. Add more pigment to your mixture, or alter the mixture by adding a different color if needed.

paint the background

Wet the entire background area with clean water. Working wet-into-wet, apply Cerulean Blue for the sky area and Naples Yellow, Quinacridone Gold and Hooker's Green for the soft-edged foliage. You can force a burst of water (see page 14) or add salt (see page 39) for texture in the foliage area. Let dry completely.

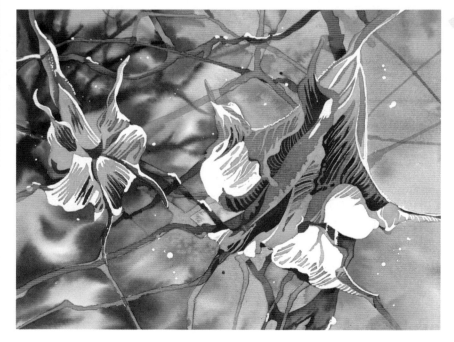

remove the masking fluid

When you are satisfied with the background, use the rubber cement pick-up to remove the masking fluid. Feel across the painting carefully to determine if all the masking fluid has been removed (almost as if you're reading braille). You can feel the residual masking fluid more easily than seeing it.

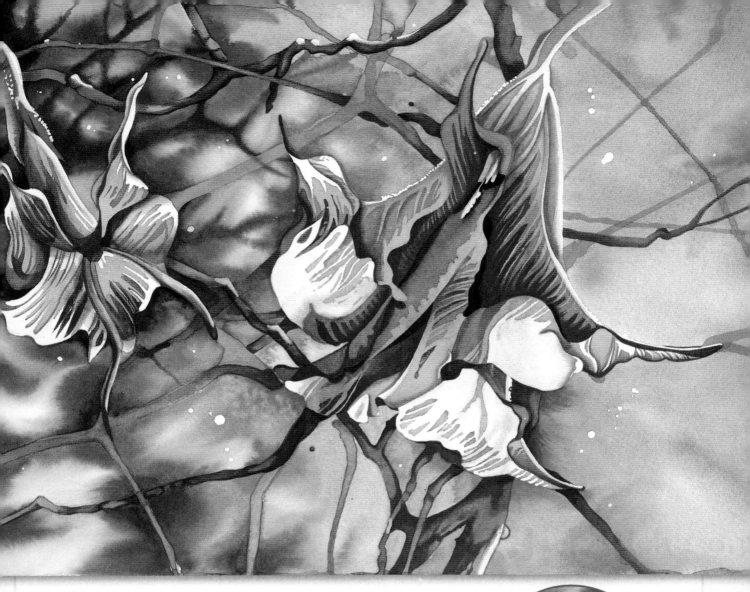

add finishing touches

Once the mask is removed, you'll probably have to tidy up the edges of the blossom and deepen values for depth and volume. You'll also need to soften a few edges—just don't try to reinvent the project by softening too many of them. This project is meant to look different from a traditional floral painting. The composition will take on a silkscreen quality with separate color areas. Enjoy the variations you have created by using this batik-like technique.

● *Moon Flowers at Renoir's Door*
 Watercolor on 300-lb. (640gsm) cold-pressed watercolor paper
 11" × 15" (28cm × 38cm)
 Collection of the artist

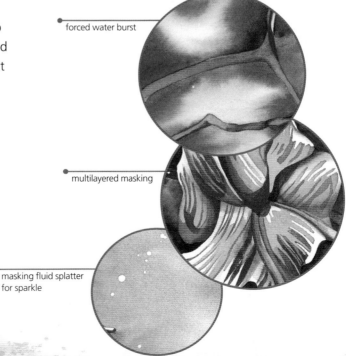

forced water burst

multilayered masking

masking fluid splatter
for sparkle

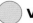

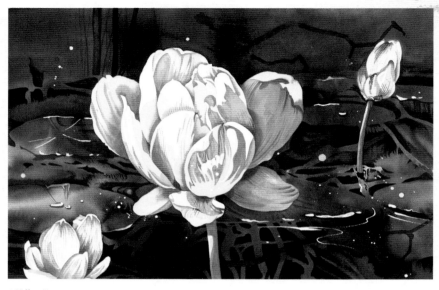

● *Yellow Lotus*
Watercolor on 140-lb. (300gsm) cold-pressed watercolor paper
15" × 22" (38cm × 56cm)
Collection of Joanne and Larry Basky

shifting values

Yellow Lotus was painted using the method illustrated in this chapter. Notice how I left the color changes separate by not softening too many edges. The drips off the poured blossoms were used as underwater roots of the water lily. The background was painted onto a dry surface, allowing the color to remain darker. Very few finishing touches were needed to complete this composition.

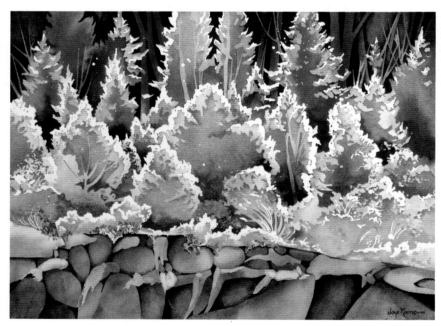

● *Frosty Morning Along the San Juan*
Watercolor on 300-lb. (640gsm) cold-pressed watercolor paper
11" × 15" (28cm × 38cm)
Collection of the artist

frozen in time

Frosty Morning Along the San Juan depicts another subject that can be conveyed effectively by pouring paint. I began this painting along the banks of the San Juan River in the southwest corner of Colorado. The frost was very thick where the sun caught the edges of the trees. I was lucky to have it last long enough to draw onto my paper. After masking out what would become the frost, I began pouring the lightest value color. I masked and poured once more to capture the subtle color shift in the trees. I used negative painting methods to finish the painting.

taking advantages of life's inopportune moments to find art

I have several artist friends who sketch daily in journals that have become diaries of their lives. This suggests that art can be found in everyday experiences. Indeed, participating in an art class or deliberately painting outdoors is beneficial to creating artwork.

But taking the time to actually *see* the environment around you and *experience* what's happening is equally important. I like to sketch in the field before I begin a painting.

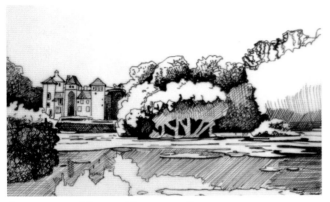

the countryside outside troyes, france

On a group trip to France in 2001, our bus was stuck in traffic because of a festival in a tiny town we needed to pass through. While the driver was backing up our huge bus for over 2 miles (3km), I had plenty of time to sketch this château and pond.

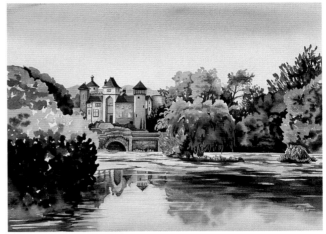

final painting

I later painted *French Country* from my sketch.

● *French Country*
Watercolor on 140-lb. (300gsm) cold-pressed watercolor paper
11" × 15" (28cm × 38cm)
Collection of Dale and Linda Martin

quick canal sketch

I quickly sketched this drawing while walking along the Grand Canal in Venice, Italy. Time was of the essence, and it didn't help that the gondolas kept bobbing up and down in the water while my art group kept walking farther and farther away without their guide. I sketched the basics and finished the drawing in our hotel room.

final painting

Gondolas are synonymous with Venice. They're such a romantic painting subject, and I couldn't wait to paint them when I got home. The initial sketch provided plenty of information for constructing the painting.

● *Gondolas*
Watercolor on 140-lb. (300gsm) cold-pressed watercolor paper
7" × 11" (18cm × 28cm)
Collection of Werner and Pat Reiher

capturing
sparkling white

Capturing sparkling white is essential for a watercolor artist. While you can employ many methods to achieve this, using the white of the paper as your true white is the cleanest and safest. I try to find the highlight shimmers, gleams and sun-dappled areas in a composition and then capitalize on them by using the white of the paper to its best advantage. We humans respond to light in a positive way. If we paint a gray-day land-scape, our mood shifts to relate to the gray gloom depicted in the scene. I love it when people look at my work and say, "Your paintings make me feel sunny inside." Sunlight uplifts our spir-its and makes us feel good. To capture this element in paint is most challenging and rewarding.

filling in the blanks

On the Rocks, Pemaquid, Maine depicts the sun shining so intensely that it actu-ally blasts the sunny side of buildings away. There is enough information at the top of the lighthouse tower and the roof of the second tower for the viewer to figure out where the left edges of the buildings are located. The brain fills in what it doesn't see. The colors run together to create secondary colors as well as semi-neutrals.

● *On the Rocks, Pemaquid, Maine*
Watercolor on 140-lb. (300gsm) cold-pressed watercolor paper
15" × 22" (38cm × 56cm)
Collection of the artist

You can't do sketches enough. Sketch everything and keep your curiosity fresh.

—John Singer Sargent

concepts & materials

contact paper masking

This project illustrates another method for saving vast areas of white, as well as tiny specks of light. Masking fluid alone is not enough to save very large areas, so we'll use a combination of contact paper and masking fluid to save the white of the paper.

thumbnail sketches

I think it's valuable to draw a thumbnail sketch of the scene you intend to paint. A thumbnail sketch acquaints you with the scene and helps you determine placement, positioning and scale before transferring the scene to your watercolor paper. A simple line drawing is enough for me, but some artists utilize a value study, which shows solid areas of light, middle and dark values for even more information.

materials list

SURFACE
300-lb. (640gsm) cold-pressed watercolor paper

BRUSHES
1-inch (25mm) and 2-inch (51mm) flats
nos. 6 and 8 rounds
no. 6 fan brush

COLORS
Cerulean Blue, Dragon's Blood, Hooker's Green, Indanthrene Blue, Quinacridone Gold

ADDITIONAL MATERIALS
masking fluid, rubber cement pick-up, palette knife, 2B drawing pencil, kneaded eraser, contact paper

sketch of trees and the calanques near cassis, france
In this 4" × 5" (10cm × 13cm) sketch I'm trying to convey the spatial changes between the trees in the foreground and the vastness of the calanques deep in the valley behind the trees.

● *The Calanques, Cassis, France*
Watercolor on 140-lb. (300gsm) cold-pressed watercolor paper
7" × 11" (18cm × 28cm)
Collection of the artist

sketch of a sunlit tuscan scene
I fell in love with this everyday scene of a woman gazing over the edge of the wall to view the beautiful Tuscan landscape. The sundappled effects enhance the composition by pouring light into the scene. A small 5" × 4" (13cm × 10cm) sketch is all that is necessary to capture these effects.

● *Wash Day in Cortona, Italy*
Watercolor on 140-lb. (300gsm) cold-pressed watercolor paper
11" × 7" (28cm × 18cm)
Private collection

creating a white sky

I've chosen Hendrick's Headlight just outside Boothbay Harbor, Maine, for the subject in this demonstration. Certain times of the day and weather conditions can create white skies. Leaving the sky white will add to the graphic quality and create a full range of value. My challenge was to save large areas of white paper so that I could easily paint juicy color to create the rocks, trees and buildings. With the white areas protected, it was fun and invigorating to be able to safely paint using the wet-into-wet method.

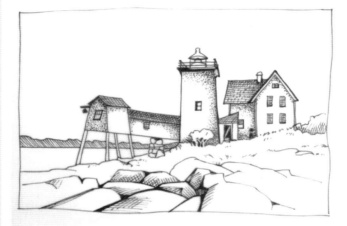

initial sketch

Eight students joined me for a week of painting around Boothbay Harbor, Maine. This is a sketch of the Henrick's Headlight. This particular lighthouse was distinctly different from other traditional lighthouses with its square tower and enclosed pier over the water.

draw the composition

Draw the composition with a sharp pencil. Try to keep your lines simple and clean. Apply enough pressure so the pencil line is a little darker than usual—you'll need to see through the contact paper to cut the stencil. Outline all the buildings, add windows and doors, and indicate where the rocks should be positioned.

trace the drawing onto contact paper

Cut a piece of contact paper large enough to cover the area you want to save. With the paper side down and the plastic side up, draw a pencil line ¼ inch (6mm) outside the buildings. You need this space to seal the edge of the contact paper with masking fluid. The shape of the contact paper can be general (i.e. not detailed).

cut the contact paper

Cut along the pencil line to create the contact paper stencil. Peel off the paper backing.

apply the contact paper

Apply the contact paper stencil. You can safely reposition the contact paper if it's not lined up the way you want it. When you're satisfied with the position, press the contact paper firmly to the watercolor paper. Apply the small pieces under the lighthouse as well. The contact paper won't stick to the paper permanently and will peel off easily when the painting process is complete.

seal the contact paper

Using a palette knife, apply a bead of masking fluid to the edge of the contact paper to seal it, as well as capture the edge of the buildings and trees. Because you're capturing the edge, be sure to apply the masking fluid with care. The masking fluid will dry exactly where you put it. Make sure the entire edge of the contact paper is sealed. Otherwise, paint may bleed under the edge.

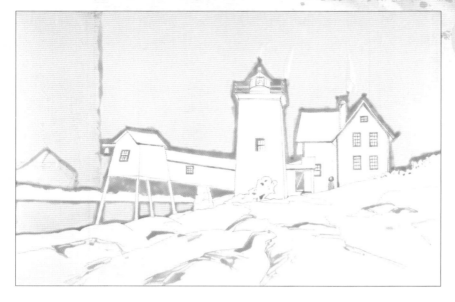

mask the details

When the contact paper is sealed, add the details of the composition such as the windowpanes, tops of rocks, grasses and shingles. If you need to patch the contact paper (as I did in the left side of the sky), seal the seam so paint can't leak beneath it.

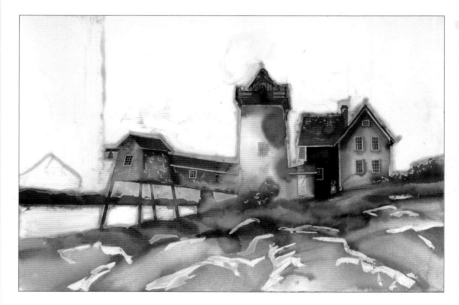

lay in wet-into-wet color

With all the white areas safely protected, you can start applying paint. First, use a 2-inch (51mm) flat to cover the entire paper with water. Start applying pigment with Quinacridone Gold followed by Dragon's Blood, Indanthrene Blue and Hooker's Green. As you apply the pigments, allow them to flow naturally across the surface. The wet-into-wet mingling will create subtle secondary colors and atmospheric soft edges. Soft edges of color will be created inside the buildings and land areas, and hard edges will form along the masked edges.

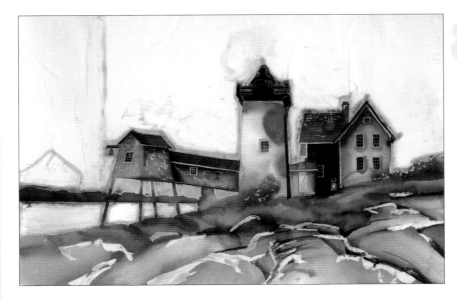

touch up the color

Evaluate the color when the painting is dry. If the values are too weak, simply rewet the paper and add more paint. You can add color to detail elements such as the space between buildings and the shadows under the windows, and to define rocks and trees.

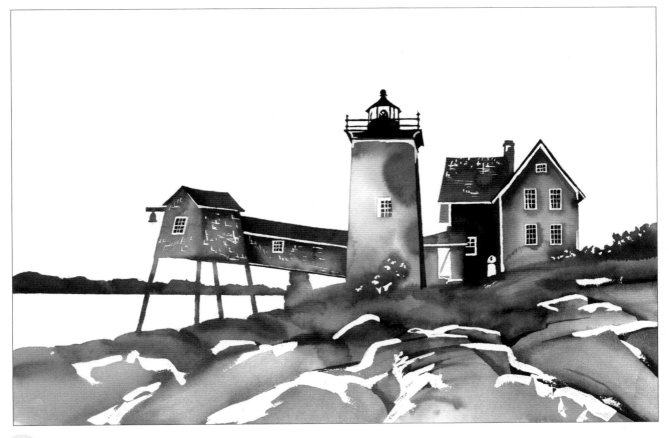

remove the masking fluid and contact paper

When the paint is dry, remove the masking fluid using rubber cement pick-up (scrape the pick-up over the masking fluid to lift it). Check for residual masking fluid by running your hand over the surface. The contact paper will peel off easily and won't leave any unwanted residue.

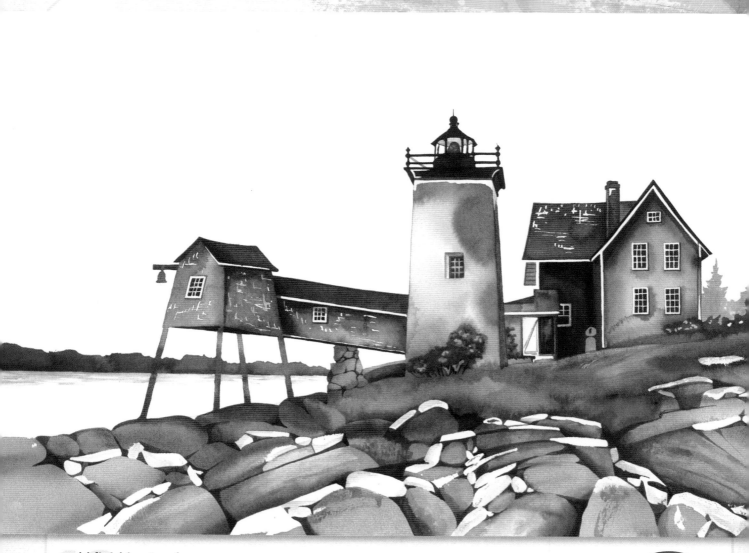

add finishing touches

After removing the contact paper and masking fluid, evaluate the painting to determine what finishing touches are needed. You may want to soften some edges, add more paint for contrast or develop rock shapes in the foreground.

I painted several pine trees behind the house to add depth to the composition. I defined the rocks further, adding to the depth and graphic quality of the painting. I used a fan brush to create grasses in the foreground. Think about using the rocks and the grass area to lead the eye into the composition.

● *Hendrick's Headlight*
 Watercolor on 300-lb. (640gsm) cold-pressed watercolor paper
 15" × 22" (38cm × 56cm)
 Collection of the artist

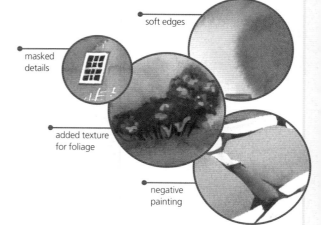

soft edges

masked
details

added texture
for foliage

negative
painting

take on true white

There are days when the sky is a true white, such as in this painting. Don't shy away from it. You can fill in the sky, but that would defeat the purpose of the project: to create an extraordinary, graphic, dramatically lit painting.

the benefits of travel

Traveling to different locations to paint is an enriching experience that helps me grow as an artist and nurtures my spirit. Since I live in Wisconsin, painting adventures that take me to Tahiti or the high desert of Mexico challenge me artistically. Colors that I'm accustomed to using in the rural landscape of the Midwest are foreign to the colors in different climates and landscapes around the world. Land formations such as mountains, waterfalls and panoramic valleys don't exist among the flat farm fields of the Fox River Valley.

Not only do I stretch my artistic vocabulary by painting in different locations, but travel enriches my life since I experience new cultures, language, music and native arts all over the world. Traveling with fellow painters creates a bond of memories that last a lifetime. It is great fun to paint side by side with other artists, and it's also a wonderful opportunity to find a park bench or a quiet alley in a tiny hill town, linger and visually drink in the scene at leisure. A cup of tea and a croissant with homemade jam contribute to the experience. I always say, "What can be more fun than eating and painting at the same time?"

canyon ride

Almost everyone in the group rode horses down into Coyote Canyon outside San Miguel, Mexico. The canyon was especially green that November because of generous rainfall that season. What a beautiful canyon and a wonderful experience to be on horseback in nature.

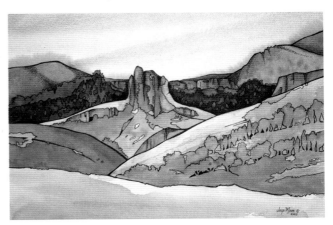

painting from memory

Since I didn't paint the day we road into Coyote Canyon, this painting is my memory of the experience that day. Sometimes participating in an experience such as horseback riding into a beautiful canyon is just as important as sitting down to paint the exact scene on the spot.

● *Coyote Canyon, Mexico*
Watercolor and ink on 140-lb. (300gsm) cold-pressed watercolor paper
11" × 15" (28cm × 38cm)
Collection of Robert and Mary Lane

triumphal demonstration

All roads did lead to Rome, and the Via Flaminia went right through the center of Carsulae. The community was a popular summer resort for Romans, with spas, theaters, a forum and twin temples.

layered composition

I started the composition featuring the triumphal arch honoring Emperor Trajan with a loose pen drawing. I then added light washes of color to complete the painting.

● *Carsulae*
Watercolor on 140-lb. (300gsm) cold-pressed watercolor paper
15" × 11" (38cm × 28cm)
Collection of the artist

CHAPTER 7

exploring
new methods

Because I believe there are many ways to paint a picture, I'm always trying to come up with new painting methods. My goal in this project was to devise a way to save the white of the paper for the aspen trees. I know that quilters often use freezer paper to transfer patterns onto fabric, so I decided to try ironing on freezer paper where the trees are located. I was able to play with color in the background while saving the trees to paint later. This method works great for the sails on a sailboat or the white foam of a crashing wave. Anything that gets my job done simply and easily is a benefit to my work and adds variety to the painting process.

saving shapes with freezer paper

In 1995, I took several groups to paint on the island of Eleuthera in the Bahamas. The banyan trees are huge and very different from any trees we have in Wisconsin. I enjoyed painting the multiple levels of tree trunks and all the tropical textures found on the island. I used freezer paper to save the white of the paper for tree trunks and to save the trunk and branch shapes after the color was applied.

● *Bahamian Banyan*
Watercolor on 140-lb. (300gsm) cold-pressed watercolor paper
22" × 30" (56cm × 76cm)
Collection of the artist

Exaggeration and modification are the undisputed prerogative of the creative artist.

—Charles Sargeant Jagger

concepts & materials

freezer paper

Here we'll learn to save white by ironing plastic-coated freezer paper onto watercolor paper. Like contact paper, freezer paper will peel off nicely after the background and foreground are painted. We'll use masking fluid to save tiny trees, and surgical gauze to create the texture of distant trees.

Using freezer paper to save the white of the paper differs from using contact paper. Contact paper, which must be sealed with masking fluid, saves large areas of white and allows you to pour or paint many layers of color safely. Freezer paper protects smaller areas of white and doesn't have to be sealed with masking fluid. Paint can slip under the freezer paper if it's not sealed completely, but this provides the added bonus of creating interesting edges and textures.

atmospheric qualities

Atmospheric conditions are an artist's dream because they allow you to create illusionary effects. For example, you can paint water particles in the atmosphere to describe depth, or depict water vapor to obscure objects in the distance. This is called atmospheric perspective. Variations of gray that move toward blue and violet recede, while warm colors advance. As a landscape moves farther into the distance, your paint should become thinner and paler and the color should become cooler.

materials list

SURFACE
300-lb. (640gsm) cold-pressed watercolor paper, 15" × 22" (38cm × 56cm)

BRUSHES
1-inch (25mm) and 2-inch (51mm) flats
nos. 6 and 8 rounds
no. 6 fan brush

COLORS
Cerulean Blue, Dragon's Blood, Hooker's Green, Indanthrene Blue, Permanent Orange, Quinacridone Gold

ADDITIONAL MATERIALS
freezer paper with plastic backing, iron, surgical gauze, craft knife, palette knife, masking fluid, no. 2 pencil, scissors

spatial changes

Artists are illusionists. It's our job to make things look three-dimensional on a two-dimensional surface. Using perspective, we suggest a plane or curved surface to depict the spatial relationship of objects as they might appear to the eye, giving the illusion of depth and dimension. For instance, in a landscape, objects such as trees appear larger the closer they are to the picture plane. Trees of the same size appear smaller farther away from the foreground. This is called *diminished repeat*. Also, detail and textures are noticeable up close but disappear as they move farther back into space.

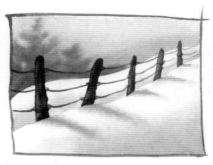

cast shadows

Another illusion you can use to clarify a scene is cast shadows. Using a landscape example, shadows cast from fence posts help anchor the post to the ground, as well as explain the flow of the land and establish depth. A shadow is stronger in color and has harder edges at the base of the fence post. As the shadow moves away from the fence post it follows the movement of the land, the color thins out and the edges become softer. Shadows can also move up vertical planes, such as the sides of buildings or anything the shadow comes in contact with.

color perspective

This term refers to the basic idea that dark colors recede and light colors advance. In this winter landscape, the top of the snow bank is the lightest because the sun is stronger at the top. Moving down the snow bank, the color gets darker since the sun can't reach the bottom. Painting the second snow mound darker creates the illusion of it being behind the first one. A cool, dark object painted behind a lighter object pushes the lighter object forward.

painting unique textures: aspen trees

When I'm in Colorado I love studying the aspen trees. They are similar to the birch trees in Wisconsin, and both are great subjects for painting texture. Aspens have a creamy, smooth surface that is interrupted by dark texture where areas have been scraped or worn away. The smooth, rounded tree trunks reflect the colors of the surrounding vegetation.

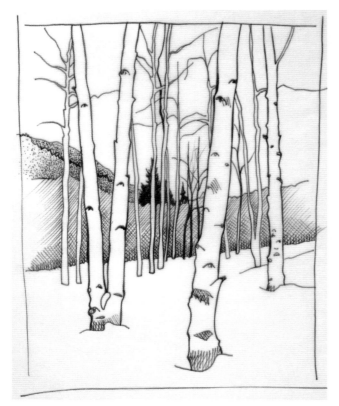

initial sketch

This 5 " × 4" (13cm × 10cm) sketch of a grouping of aspen trees located outside Pagosa Springs, Colorado. Aspens have such a simple shape, yet when they grow closely together they create a family of trees and a more complex composition.

draw the composition

Using a sharp pencil, draw the composition on watercolor paper. Position the aspen trees at various levels to create a compositional lead-in and to portray depth of field. Initially, the viewer's eye will begin at the large tree at the bottom of the composition. The aspen trees progress back into the landscape, moving the viewer's eye to the mountains and sky. Feel free to add or subtract trees to fit your composition.

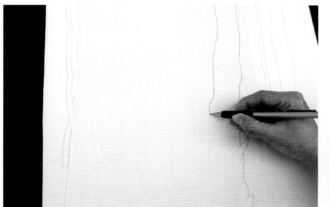

cut freezer paper

Place the freezer paper, plastic side down, over the trees you want to keep white. Carefully trace the tree shapes and cut them from the freezer paper using scissors.

apply the freezer paper

To apply the freezer paper, press it—plastic side down—over the large tree shapes. Using an iron (set either on "linen" or "hot"), adhere the freezer paper to the large tree shapes.

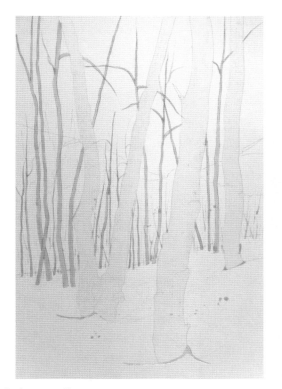

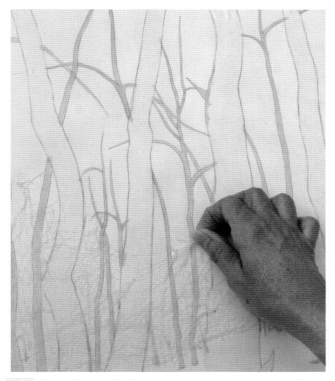

mask the smaller trees

To save the whites of the smaller trees, use a palette knife to fill them in with masking fluid. I also saved the edge of snow at the base of the trees with masking fluid. Finally, I splattered the masking fluid from the palette knife to save sparkles of white (see page 49).

position the surgical gauze

Using the 2-inch (51mm) flat, wet the top of the paper where the snow area meets the background. This will hold the surgical gauze in place and help you position it into the tree line area. Position the surgical gauze in the tree line area.

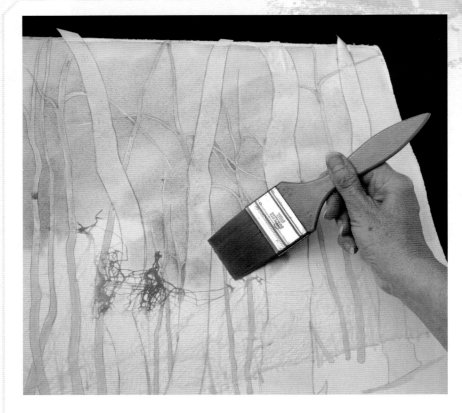

paint the sky

You may need to rewet the sky and tree area with water if it starts to dry. Using a 2-inch (51mm) flat brush, apply Cerulean Blue to the sky area. Let this area dry a bit before painting the surgical gauze.

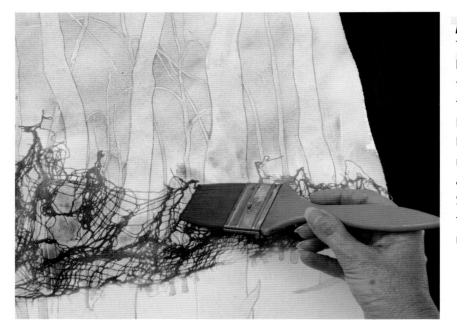

paint the background trees

To create the effect of trees in the background, use a 2-inch (51mm) flat to apply a variety of pigments to the gauze area: Quinacridone Gold, Hooker's Green, Cerulean Blue and Dragon's Blood. Make sure the pigments are saturated enough to make a good value contrast next to the sky. Since the area is wet, you don't need to blend the different colors; they'll mingle on their own.

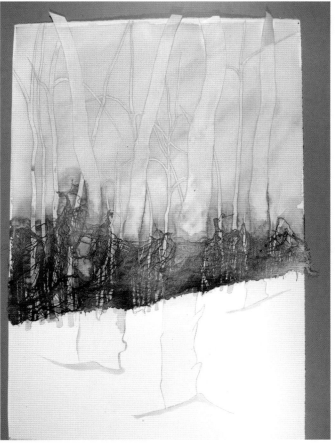

detail the tree line

When it's dry, remove the surgical gauze. Paint any details needed to complete the tree line area using the colors from step 7. Using the no. 8 round and the same colors, you can darken the area along the bottom where shadows would occur naturally.

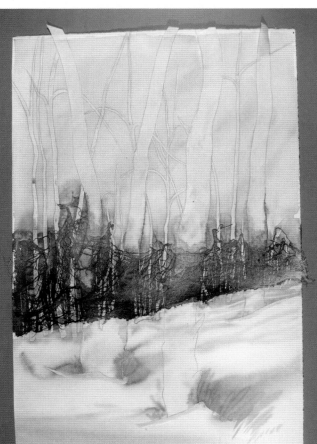

paint snow and grasses

Wet the snow area with clean water using the 2-inch (51mm) flat brush. While still wet, use Cerulean Blue and Indanthrene Blue to create the shadows from the aspen trees with a no. 8 round. Your brushstrokes should follow the contour of the snow and give a sense of flow to the snow area. The color should be stronger at the base of each tree and then thin out as the shadow moves farther away. While still wet, paint the grasses with Quinacridone Gold and Dragon's Blood. These grasses will have soft edges at this point.

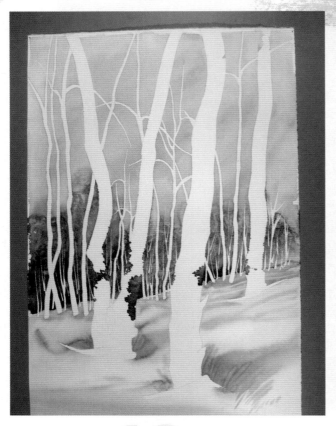
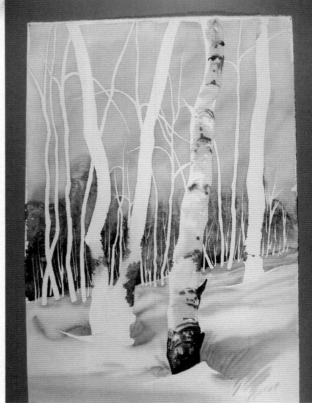

paint the aspen trees

Peel off the freezer paper. It will come off easily and not leave any residue. Use the rubber cement pick-up to completely remove the masking fluid from the smaller trees and any other areas. Using a 1-inch (25mm) flat brush, wet the trunk of a tree intermittently, leaving part of the trunk wet and part of it dry. Apply a thin layer of Permanent Orange on the shadow side of the tree. Where the area has been moistened, the color will look soft edged; where you left the area dry, it will appear hard edged. This creates variety along the tree trunk. Apply light, wet-into-wet touches of Cerulean Blue and Indanthrene Blue down the center of the trunk to contour the shape by providing subtle shadows.

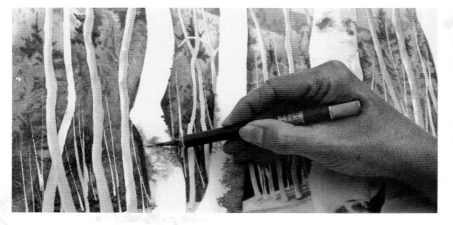

scrape the paint

If color seeps under the freezer paper, you can incorporate it into the texture of the tree. Use a craft knife to scrape up some of the color. If you scrape horizontally, you can even create the appearance of aspen bark.

add finishing touches

You can add some darks for contrast in the gauze tree area. Remember to add a bit of Permanent Orange, Dragon's Blood and Cerulean Blue to the smaller trees in the background, especially along the shadow side of the tree. To finish the tiny branches on the aspen trees, use a combination of palette knife and no. 6 round brush to apply color. The variation will enhance the randomness seen in nature. You may need to add extra color behind a snowbank to give the viewer a bit more information about the flow of the land under the snow. You can even add a mountain range in the background if you think the composition would benefit from another spatial change in the distance.

● *Colorado Aspens*
 Watercolor on 300-lb. (640gsm) cold-pressed water-
 color paper
 22" × 15" (56cm × 38cm)
 Collection of the artist

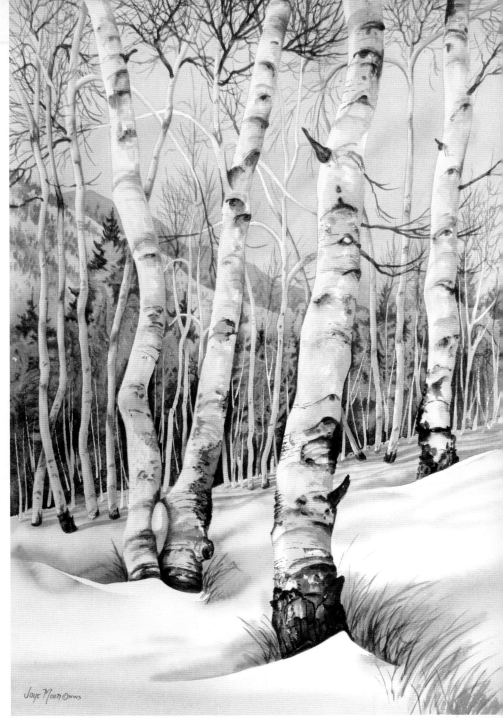

Joye Moon ©NWS

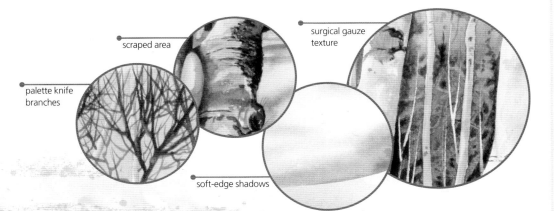

palette knife
branches

scraped area

surgical gauze
texture

soft-edge shadows

prouts neck

Working from photographs I took at Prouts Neck, Maine, I constructed this painting by using freezer paper to save the white crashing wave, as well as the water floating on top of the rocks. The spray was achieved by splattering masking fluid from a palette knife to create the larger water droplets. Finally, I splattered masking fluid from a toothbrush to create the tiny droplets of water. I then applied the wax paper over rich, juicy, wet paint.

⬤ *Crashing Wave at Prouts Neck, Maine*
 Watercolor on 300-lb. (640gsm) cold-pressed water-color paper
 20" × 22" (51cm × 56cm)
 Collection of the artist

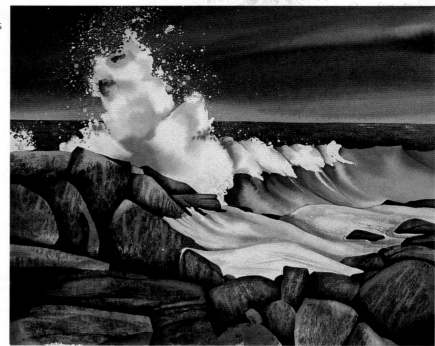

flowing color

Blue Cypress was created by using contact paper to save the white of the paper. I also used masking fluid to save the tiny spaces between the branches. The colors commingled on the exposed paper surface.

⬤ *Blue Cypress*
 Watercolor on 140-lb. (300gsm) cold-pressed water-color paper
 15" × 22" (38cm × 56cm)
 Collection of the artist

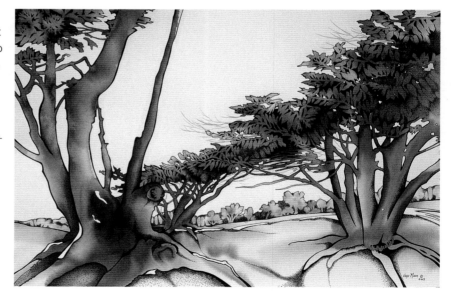

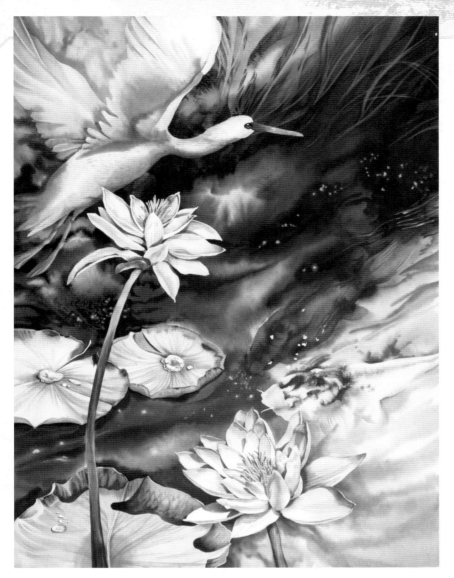

evening reflections

I used freezer paper to save both the bird and the lotus blossoms. I could safely paint the entire background with ease knowing my whites were saved for later. The spots of masking fluid were softened using a craft knife. I gently scraped away the outer edge, creating a reflecting star on the surface of the water.

● *Moonlight*
Watercolor on 140-lb. (300gsm) cold-pressed water-color paper
30" × 22" (76cm × 56cm)
Collection of Kenneth and Beth Campshure

removing masking fluid

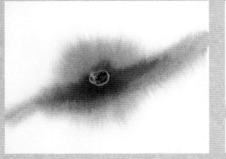

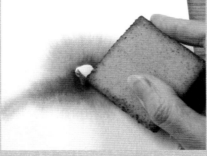

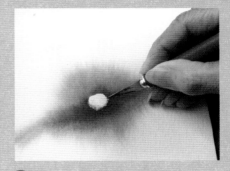

1 Apply color over the masking fluid.

2 Remove the masking fluid with a rubber cement pick-up when the paint is dry.

3 Hold the craft knife as if you're holding a pencil and gently scrape off paint at the edge of the masking fluid shape. Notice the soft edge around the masked area.

CHAPTER 8

color, shape
and movement

So, you don't have any subject ideas? Not sure what colors to choose? Your paintings look tight and you need to loosen up? Never fear! Let's paint by the seat of our pants with this project.

We'll experience painting without rules: no preplanning, no drawing a composition, and absolutely no idea what the painting will eventually develop into. This is a new way of playing with paint that will recharge your creative batteries.

Working intuitively will broaden your arsenal of creative knowledge. As you scatter different types of salt, splash alcohol drops, sponge paint and scrape watercolor pencils, you'll experience a sense of freedom and spontaneity while incorporating these substances into your work.

experimental fun

Aqua Cascade is a fun, free flowing painting that I developed with surgical gauze, wax paper, plastic wrap, a variety of salts, alcohol drops, color lifting and splattering and lots of negative painting. Let's just say, playing with paint and different substances is *big fun*!

● *Aqua Cascade*
Watercolor on 140-lb. (300gsm) cold-pressed watercolor paper
22" × 30" (56cm × 76cm)
Collection of the artist

Just put a mark of paint on a canvas and let yourself carry on directed by hidden instinct. That takes courage. To control but yet not to control.

—Moncy Barbour

concepts & materials

working method

Creating a painting with no plan or preconceived idea can be daunting as well as worthwhile. Your creativity will be stretched to the limit because you're not plein air painting a landscape, working from a still life or even from a photograph. Ideas will spring from your imagination, and fun details will emerge from the materials you incorporate into the project.

Although I said this is a "no rules" project, a few procedures will help the process.

1. Start painting with big brushes, then move to small brushes. Each brush creates a different stroke, so use a variety.
2. Work from thin paint to thick paint ("fat over lean"). Dilute your first color choices and, as the painting progresses, use more heavily saturated pigments for good value changes.
3. Keep your mind-set loose and open; don't try to paint tulips, roses and daisies. The only thing you need to accomplish in the first phase is color, shape and movement. The colors and shapes should move in pleasing patterns on the paper surface. Just play with paint and have fun!

value

Each paint color can be either diluted for a thin veil of color or left heavily saturated with pigment for a dark value of the same color. There is an infinite number of values between the two extremes.

brushes

You can create many different strokes with one brush just by positioning the brush differently or applying more or less pressure while painting. Examine the variety of examples of brushstrokes below.

pure-hue value	low dark	middle dark	high dark	middle value	low light	middle light	high light	white

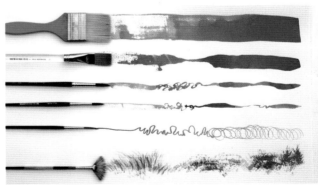

value scale

The standard value scale uses seven basic values that are located between the white and black. Of course, some of the lighter colors, such as yellow and orange, can't get as dark as black, but the idea is to have the color as saturated as possible to explore it's full range of value.

brushes

Here are the brushes I use most frequently. From top to bottom, they include:

- 2-inch (51mm) flat
- 1-inch (25mm) flat brush
- No. 8 round
- No. 6 round
- Rigger brush
- Fan brush

painting abstract florals

This abstract project will take on a floral theme. We already have all the flower power we need in our mind's eye. Leaf shapes can be long and thin, heartlike, curly-edged or frilly (e.g. ferns). Petals can be tiny (e.g. daisies) or large (e.g. hibiscus and petunias). I call these paintings "Moon hybrids" because the flowers I create can be anything I want.

Now, just let the creative energy flow!

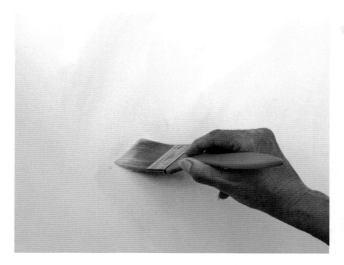

apply the first color

To keep the paper wet longer (and maximize your play time!), place your paper on a Formica tabletop or a sheet of Plexiglas. Using the 2-inch (51mm) flat brush, wet both sides of the watercolor paper. Have your spray bottle handy to keep the entire piece of paper evenly wet. (The edges dry out first so pay attention to them.) You want the first phase to consist entirely of soft edges.

Pick a color that inspires you (I chose Naples Yellow). Dilute the pigment to create a relatively light value, then paint areas of the paper using a 2-inch (51mm) flat. Take some color off the edge of the paper; you don't want all the color to be confined to the center of the composition. When you paint, think only in terms of *color*, *shape* and *movement*.

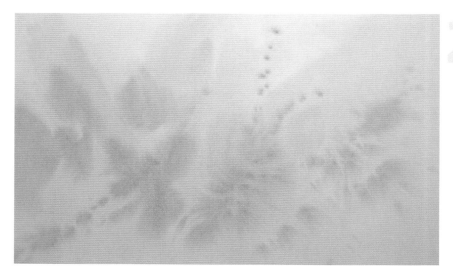

apply the second color wet-into-wet

To achieve a darker value than the Naples Yellow, I splattered Permanent Orange from the 2-inch (51mm) flat brush. Whenever you catch yourself tightening up or thinking about painting a specific flower, load your brush with paint and splatter your paper.

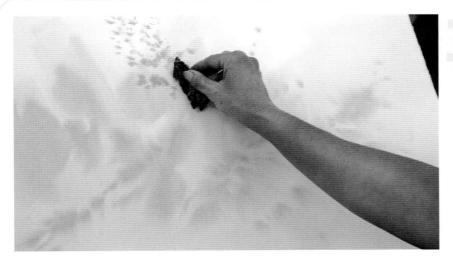

sponge color

Load a damp natural sponge with thinned Magenta. Apply it here and there around the paper, using different areas of the sponge to avoid repeating the same texture. Don't forget to spray the paper with water to prevent it from drying.

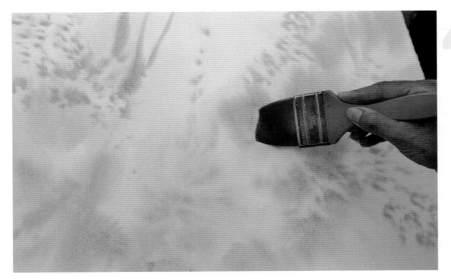

apply another color

I combined Hooker's Green and Permanent Orange to create a soft, mossy green, then applied it using a 2-inch (51mm) flat. (I thought the Hooker's Green by itself would be too strong for the soft colors I'd already applied.) Don't think of green as a background color or limit its use to carving out positive flower shapes. Use it to enhance the color, shape and movement of the overall design.

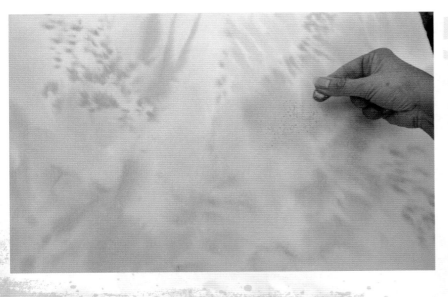

sprinkle with popcorn salt

Sprinkle popcorn salt on a few areas for soft texture. Popcorn salt is the finest grain of salt, which gives you a gentler texture. Remember: Salt has to be sprinkled into wet paint and left until the painting dries to create texture.

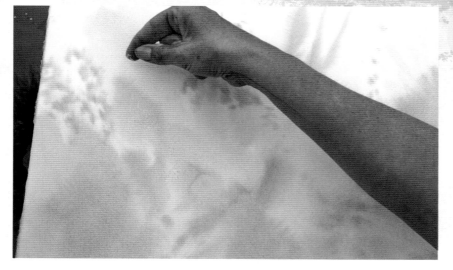

sprinkle with table salt

Sprinkle table salt on other areas for more texture. Table salt will produce denser texture depending on when it's applied: If the paper is very wet, you'll get a loose texture as it dries. If the paper is only moist, the salt will produce little snowflakes of texture.

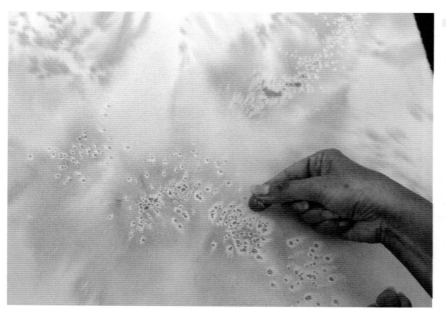

sprinkle with epsom salt

For a large burst of texture, sprinkle Epsom salt. Epsom salt is the largest salt grain and creates a more dramatic effect. (Pickling salt and kosher salt have a similar effect.)

Remember to keep your paper evenly wet.

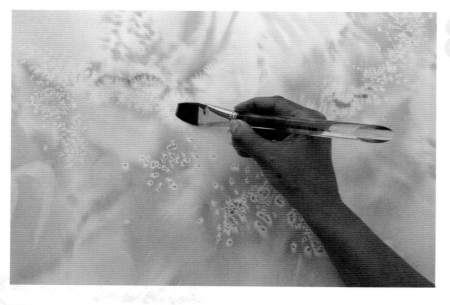

force a burst of water

Using clean water and a 1-inch (25mm) flat brush, force a burst of water to create frilly-edged shapes.

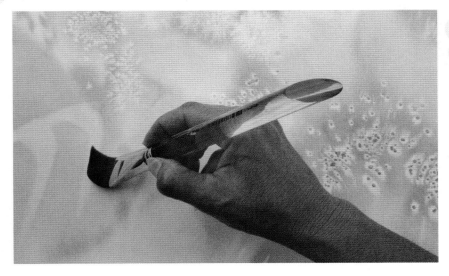

lift away color

When the paint starts to dry, use the 1-inch (25mm) flat brush to lift some color. Lift in varying strokes to create thin shapes for stems, or curved shapes for leaves. Although the painting is still fairly abstract at this point, you can interpret the lifted areas as positive shapes.

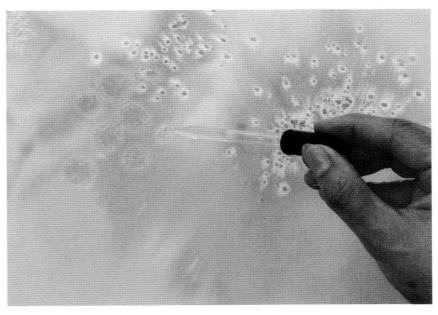

alcohol drops

Using an eyedropper, apply several drop of isopropyl alcohol to create small, rounded shapes. You will enhance them later to make them appear more dominant. Take care not to inhale the fumes because they can be hazardous to your lungs if you work with alcohol frequently. Consider wearing a mask.

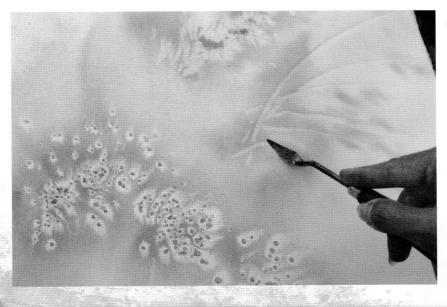

scrape color away

Use the palette knife to scrape away color. Use strokes that suggest grass or leaves. The paint should be just starting to dry so the scraped paint doesn't flow back into the area.

consider your composition

Note how the various salts dried, and how frilly edges were created by the forced burst of water. The lifted and scraped areas have a nice balance and add variety to the composition. Notice how the paint dried 20 to 30 percent lighter; this is because it was painted wet-into-wet.

At this point (phase two), it's time to identify interesting areas that will become positive shapes. By negative painting—painting around these shapes—you'll create the flowers and leaves. If you're unsure about finding positive shapes, go ahead and draw the shapes you want to save. I tell my students, "There is no honor in *not* drawing on your shape ideas before you start to paint the background."

The beauty of the shape might go beyond the salt texture or scraped line. Think about leaving a halo of color beyond the textured areas; that's where the magic happens.

I identified this shape as an interesting area. Because I love the beautiful halo of green bleeding into the area around the shape, I didn't cut it off by painting up to the edge.

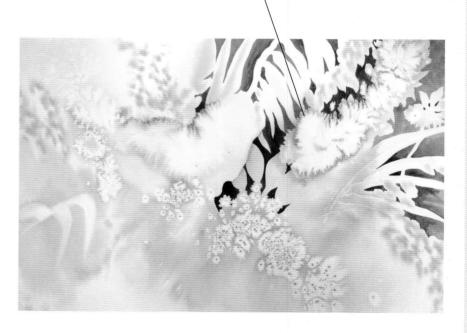

capturing shapes

Keep the surface dry to capture the hard edges of flowers and leaves. Create background pigments with the colors used in phase one. The background color can be close in value or distinct. Changing the value of the background pigment will enhance the random variation that would be found in a garden. I began creating the shapes by painting around them using a no. 8 round with a combination of Hooker's Green and Burnt Sienna. (I thought the Hooker's Green was a bit too sharp and bold on its own, so I neutralized it a bit.)

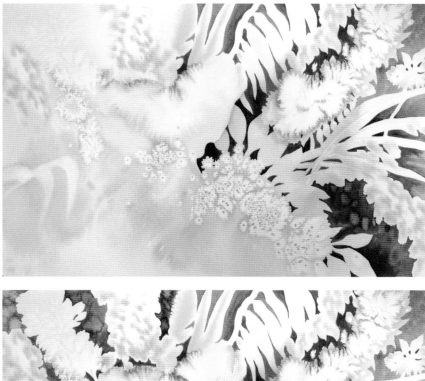

vary the background colors and continue adding texture

I wanted to expand on the sponged Magenta areas, so I painted the background using a no. 8 round and echoed the texture by forcing bursts in the wet paint. The darker value will look like it's behind the lighter value.

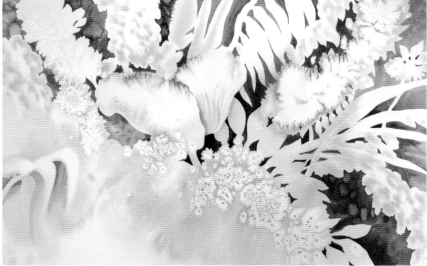

find a variety of sizes

Continue to find different sizes of blossom and leaf shapes. Vary the background color to avoid making it look too solid behind the flowers. The background doesn't have to be uniformly dark; it can remain a light value as well.

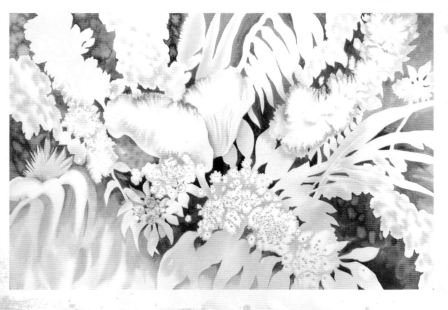

continue negative painting

Continue to paint the negative space behind your positive flower images. Finish the background and evaluate your results. Think about what edges need to be softened, and if there are background areas you can divide into more shapes.

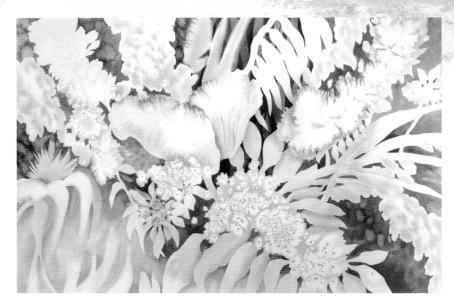

add depth
At this point, your positive shapes will look flat yet interesting. Add shadows to some petals to make them appear as if they're above or behind another petal. Go deeper into the background by painting more shapes into the negatively painted areas. I added more leaves to the negatively painted area at the top center of the composition to enhance the depth in the composition.

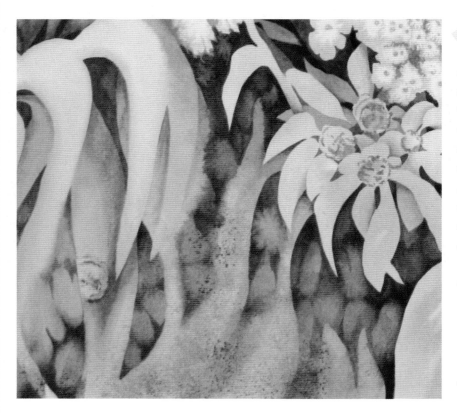

add watercolor pencil shavings
Push some elements back and introduce another texture by adding watercolor pencil shavings. Wet the area first, then scrape the watercolor pencil where needed. Since each painting calls for different solutions, you might choose colors that are similar to what's already in the area. Conversely, light colors might be needed to brighten, or darker colors to fill in or darken an area. I chose watercolor pencils in Mars Violet, Light Orange and Moss Green Light.

Demonstration continues on page 84.

Be Bold. It's just canvas, just paint. If it doesn't work for you, paint over it and start again. Don't be afraid that you are wasting supplies. Every failure teaches something, if only what not to do.
—Tiko Kerr

creating texture with pigment shavings

This is my favorite technique to use with watercolor pencils. I sprinkle shaved pigment onto a wet surface to create beautifully colored areas of texture. Woodless watercolor pencils, such as Cretacolor Aqua Monolith Watercolor Pencils, work best for this technique.

When it comes to shaving the pigment, you can use any tool. I use either sandpaper (for a finer pigment grain) or a nutmeg grater (for a larger grain). The sprinkled color can be reactivated with a wash of water.

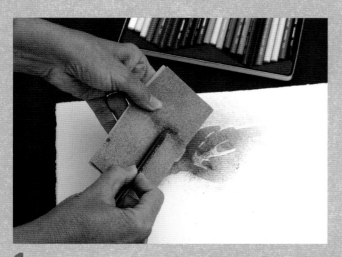

1 Scrape the woodless watercolor pencil over sandpaper and let the shavings fall onto a wet surface. The sandpaper produces a fine dust of color, some of which will dissolve on the wet surface and commingle to create a textured area of color.

2 When the area is dry, blow the excess pencil dust off the paper, leaving the shape you sprinkled on the surface. This is a great technique for enhancing background areas or highlighting the tips of flowers and leaves. Notice the fine texture of color from the sandpaper shavings.

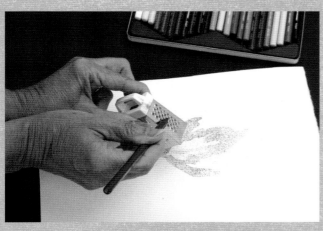

1 Scrape a watercolor pencil over a small-toothed nutmeg grater, letting the shavings fall into a wet area. Grate multiple colors over the wet area to create different mixtures. The nutmeg grater will produce a larger flake of pigment than sandpaper, creating a large dot of color.

2 Use a wet brush to further activate the pigment particles and create a solid look. Here, I used a wet brush to expand the veining of the leaf shape. Because the nutmeg grater produces larger shavings, the pigment dots are farther apart and you can see more white of the paper.

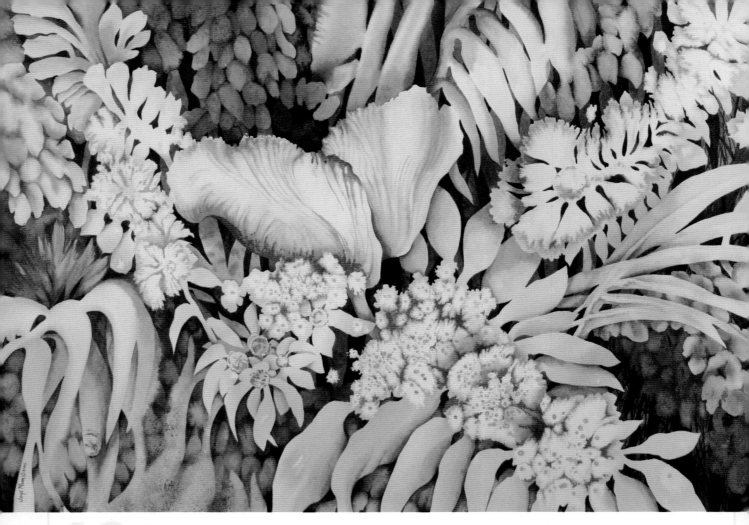

soften the edges

At this point, there may be a lot of hard edges, so you might need to soften petals and leaf shapes to balance the composition. Using a damp brush, reactivate the color along the edge of an object. Keep lifting color until there's a pleasing, soft edge. Sometimes I run color from the background over the hard edge to soften it and to make the object look as if it's moving into shadow. Evaluate the various colors throughout the painting; do you need to glaze subtle color here and there to balance the color families?

● **Summer Bounty**
Watercolor and woodless watercolor pencil on 140-lb. (300gsm) cold-pressed watercolor paper
15" × 22" (38cm × 56cm)
Collection of the artist

popcorn salt

table salt

palette knife scraping

sponging

Epsom salt

forced water burst

woodless watercolor pencil shavings

lifted paint

⬤ variations

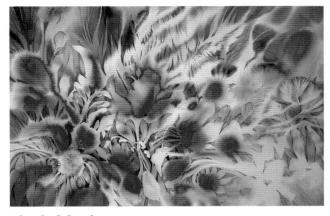

island of eleuthera

Bahamian Blossoms is my impression of the beautiful tropical flora found in the Bahamas. The vibrant colors and unusual textures of the vegetation made for an interesting composition. With this painting, I actually tried to replicate flowers found on the island of Eleuthera. I painted a red-orange during the wet-into-wet phase. I later shaped the blossoms into the flowers that grow on the poinciana tree. The green areas were initially created by forcing bursts of water and later developed into fern-like leaves.

● *Bahamian Blossoms*
 Watercolor on 140-lb. (300gsm) cold-pressed watercolor paper
 15" × 22" (38cm × 56cm)
 Collection of the artist

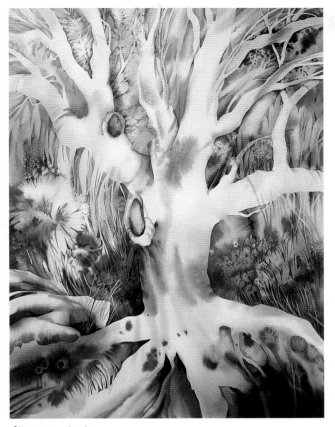

diverse painting

Into the Woods is a landscape example that uses many of the techniques found in this chapter. Popcorn, table and Epsom salts, alcohol drops, forcing bursts of water and scraping with a palette knife were used to create a variety of textures. These textures weren't used extensively as subject matter. I let the textures gently combine as a part of the background. Negative painting completed the composition.

● *Into the Woods*
 Watercolor on 140-lb. (300gsm) cold-pressed watercolor paper
 30" × 22" (76cm × 56cm)
 Collection of the artist

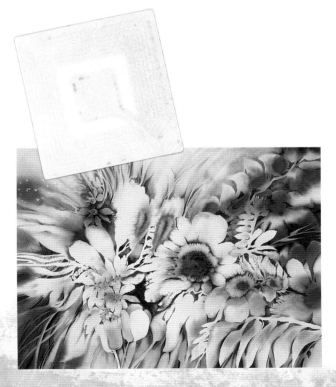

color nuances

Floral in Blue and Orange was painted with only two pigments, Permanent Orange and Ultramarine Blue. Limiting your palette by using complementary colors can produce a wide variety of neutrals and interesting secondary colors. It forces you to push the subtle color nuances to the fullest, making the color value most important. I used salt areas for the center of flowers and developed drops of alcohol into small flowers. Scraped areas of paint turned into leaves by negative painting the background. I lifted out thin leaves and twigs, adding depth to background areas.

● *Floral in Blue and Orange*
 Watercolor on 140-lb. (300gsm) cold-pressed watercolor paper
 22" × 30" (56cm × 76cm)
 Private collection

brush techniques on gesso-primed paper

In this project, you'll paint on a gesso-primed watercolor paper. Since the gesso is acrylic, watercolor paint won't adhere completely to the surface. Lifting paint is easy, but layering paint can be difficult. You can apply the gesso with a brush or palette knife to create patterns and textures. Once you apply the watercolor paint, however, the effects look similar to an oil painting, especially if you applied the gesso with a brush or a palette knife.

featured surface

140-lb. (300gsm) cold-pressed watercolor paper

Steve Quiller Acrylic Gesso by Richeson

1 apply gesso with a brush

To create an interesting texture with the gesso, apply it thin in some areas and thicker in others, then swirl your brushstrokes in the thick gesso areas.

2 apply gesso with a palette knife

Since my composition would be a stream flowing over rock, I used the palette knife to scrape the gesso into place to accentuate the path of the water. You can use a brush for some areas and then switch to the palette knife to carve designs needed for your composition.

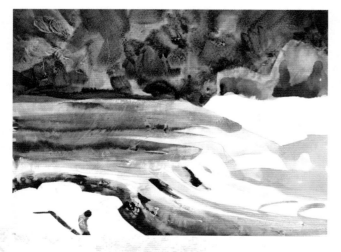

3 apply color

To keep the color rich, thick and dark, use the wet-into-dry method so your paint isn't diluted by the wet surface. I painted the entire background, applying yellows, greens and blues in a random fashion. I then switched to the wet-into-wet method for the water area to create the flow of water.

The more texture you create with the gesso using your brush and palette knife, the greater the variety of texture you'll achieve with your final painting.

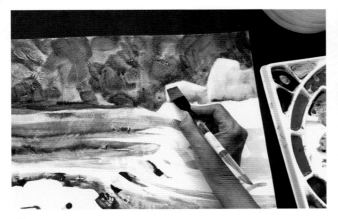

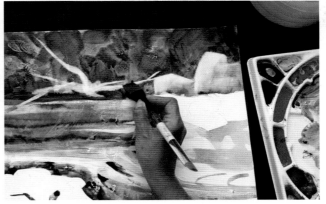

4 *lift paint*

Using a 1-inch (25mm) flat, lift color from the rock area. I used Indigo, which is staining. The paint stained the gesso and created an interesting glow of blue on the rocks.

5 *lift additional elements*

Lift the tree shape from the background and any additional elements using a 1-inch (25mm) flat brush. For the tree, vary the pressure on the brush to create a stroke that's wide at the bottom and then tapers off.

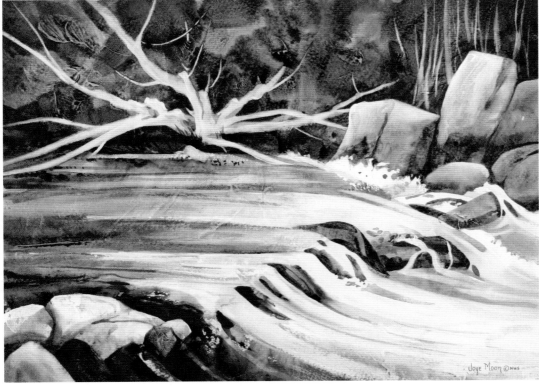

6 *complete the painting*

Fill in any remaining areas with paint, using wet-into-wet or wet-into-dry as the area suggests. Use a palette knife to scrape some additional branches. I completed the painting by using acrylic paint to establish some pure white highlights. Notice the effect of the paint over the scored gesso area in the flowing water. It adds texture and dimension to the painting.

● *Pike River Rapids*
Watercolor and acrylic on gesso-primed 140-lb. (300gsm) cold-pressed watercolor paper
11" × 14" (28cm × 36cm)
Collection of the artist

CHAPTER 9

abstract
landscape

How comforting it is to know that creativity never gets worn out or used up. The possibilities are endless. If you can imagine and dream, you can bring your thoughts into reality. Creative visualization regarding your artwork can become a part of your daily thought process. Always "push the envelope" by challenging yourself creatively. Risk it all. Everything you learn will be reward enough.

mix casein and watercolor for atmospheric effects

This painting is a fantasy landscape that incorporates the methods explored in this chapter. I mixed casein with watercolor to achieve a soft, atmospheric quality, which sets the mood for the painting.

● *Along the Mountain Side*
Casein and watercolor on 140-lb. (300gsm) cold-pressed watercolor paper
22" × 30" (56cm × 76cm)
Collection of the artist

An artist must evolve to quell the voice within and find new ways to speak unspoken ideas.

—William Scott Jennings

concepts & materials

some general guidelines

There aren't any limitations with this project, but there are a few things to keep in mind.

1. When placing the plastic wrap, wax paper and surgical gauze, you want to create movement. Place these items so that they relate to each other and aren't just floating in their own environment.
2. The textures created by these materials will be interpreted later, so don't think of the plastic wrap as only a water area, or the wax paper texture as rocks, or the surgical gauze as foliage. Keep an open mind regarding the composition.
3. Don't try to force the shapes into compositional elements in the early stages. As we discussed in Chapter 8, think of color, shape and movement. The composition will be developed later.

a path through an imaginary forest

There are many ways to direct the viewer's eye through a painting. The focus on a subject and the movement in and around a painting is the viewer's invitation to walk into the scene and explore. A pathway can be established by using bright colors placed strategically to draw the viewer into the composition. Textured areas adjacent to nontextured area also create a pathway. Traditionally, the center of interest is a compositional device that moves the eye. Sometimes, the center of interest is strong enough to draw the eye directly to it. The artist can also play with the composition to move the viewer's eye around the painting before settling on the main subject.

strong colors
Lead into the painting through an arrangement of strongly colored rocks.

unique textures
Lead the eye into the composition with a textured grass pathway.

flowing water
Lead in through flowing water, such as a stream or creek. A road or footpath has the same effect as the waterway.

pushing the boundaries: painting without a plan

When you begin a painting with no set plan, you allow it to evolve into what it wants to be. Remember, a tree trunk doesn't have to be brown and a sky can be purple or green. Don't impose limitations on your creativity. Explore all the possibilities, from first wash to the finishing touches.

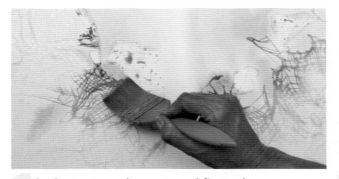

apply the texture elements and first colors

Position the paper on the Plexiglas or Formica (this will keep it from drying out too quickly) and use the 2-inch (51mm) flat brush to completely wet the front and back of the paper. While the paper is still wet, position the surgical gauze, the plastic wrap and then the wax paper. Spray the edges of the paper with fresh water if it starts to dry. Apply some light color using the 2-inch (51mm) flat brush—I began with Naples Yellow, followed by Quinacridone Gold. When applying the paint, keep in mind the movement already established by the other elements.

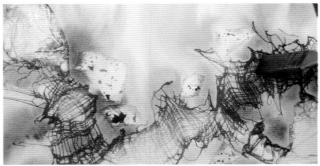

vary the paint colors

Continue adding color, applying darker values for contrast. I used Dragon's Blood, letting it mingle with the yellows to create some earthy oranges, and began adding Hooker's Green.

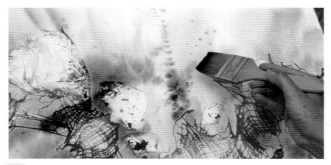

splatter

Use the 2-inch (51mm) flat brush to splatter color randomly. Here, I'm attempting a vertical splatter of Hooker's Green to balance the horizontal aspect of the gauze. It commingles with the oranges and yellows to create a variety of greens.

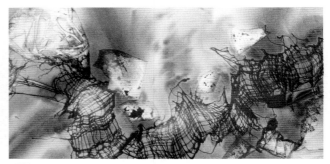

add areas of heavily saturated pigment

Switch to a smaller brush (such as the 1-inch [25mm] flat) to produce areas of heavily saturated pigment. Spray with water if any areas begin to dry. You want the edges to stay soft at this point. Remember to leave some white of the paper for sparkle so you can achieve a full range of value in the painting. Remove the surgical gauze.

continue adding texture

Before the surface dried I used a 1-inch (25mm) flat to lift paint, as I did in the upper-left green area. Some of the top is beginning to develop upward paintstrokes that will be interpreted as trees later. Add additional texture by loading your brush with clear water and forcing bursts.

Take a moment to look at the results. The paint will appear much lighter when dry. There are subtle differences in how textures look when applied to wet paper vs. a painted area.

find the shapes

Start identifying areas that can be trees, shrubs, rocks, grass—even water. Turn the composition in all directions. Sometimes the direction you originally painted the composition might not be the most exciting. Think about using the surgical gauze as the texture for a tree trunk or a backdrop for the scene.

I identified tree shapes at the top. I enhanced the red tree area by painting branches, letting the color thin out towards the sky background. This gives the appearance that the sunshine in the middle is fading the outline of the branches. I used the green area on the left to create more tree shapes. There seemed to be a pine tree behind the clump of green trees so I started to define that as well.

go deeper into the forest

Continue adding different sizes of trees and unusual rock shapes using the negative painting method. I used a combination of painting wet-into-dry and wet-into-wet when I wanted paint to bleed. Think in terms of the composition in its entirety.

search for more detailed images

Looking deeper into the textures, I found a shrub growing out of a rock on the right. I left the lower left side open to be developed later into a falling water area. I began to develop rocks along the bottom right.

painting rocks

Students sometimes find it difficult to locate rock shapes. For years I've taught an easy method for finding rocks, even when there's no texture to begin with. I never get upset about trying to make rocks look exactly like rocks. If my rocks end up looking like baked potatoes, I think I've been successful.

1 Start by painting triangles wherever you like. Create long and rounded triangles, as well as big and small triangles. Place the triangles randomly.

2 Paint circles to connect the triangles and identify the rock shapes. You may have to paint more triangles to fill in the rounded shapes. Think of the triangles as the shadow shape where two or three rocks come together.

3 Finish the rocks by using a dry-brush method to contour the rocks. Apply the paint darkest in the shadow areas. You may even find small rocks inside the large triangles.

4 Finish the rocks by intensifying the forms and shadows.

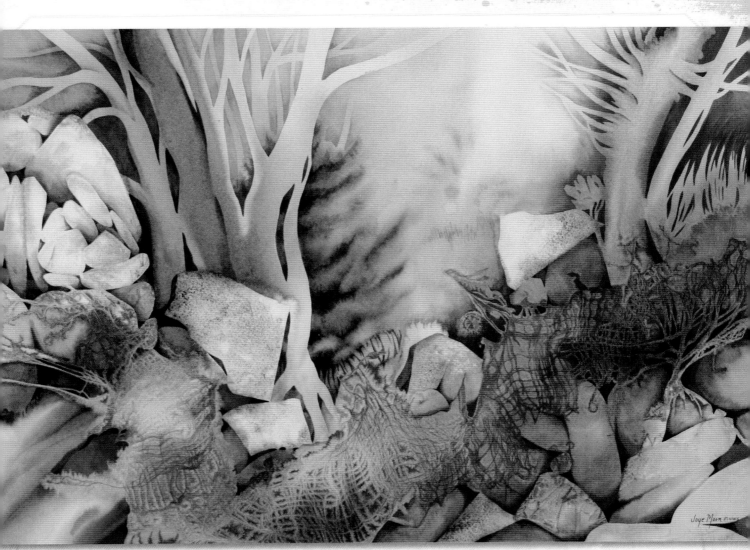

completed project

Using darker, more saturated pigments, define landscape elements such as water, rocks and trees. Push the values with saturated pigments.

The finished project is still recognizable as a landscape yet has a spontaneous quality. The initial wet-into-wet phase sets the tone. You can give the viewer as much or as little detail information as you like. Engage the viewer by letting them figuring out elements for themselves.

● *Lone Pine Tree*
Watercolor on 140-lb. (300gsm) cold-pressed watercolor paper
15" × 22" (38cm × 56cm)
Collection of the artist

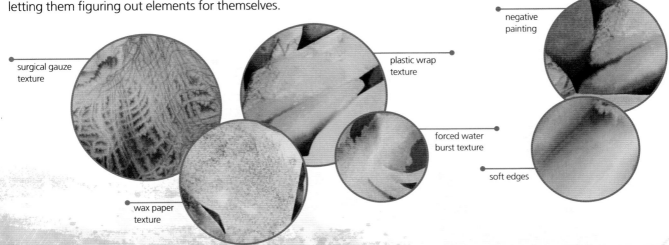

surgical gauze texture

plastic wrap texture

negative painting

forced water burst texture

wax paper texture

soft edges

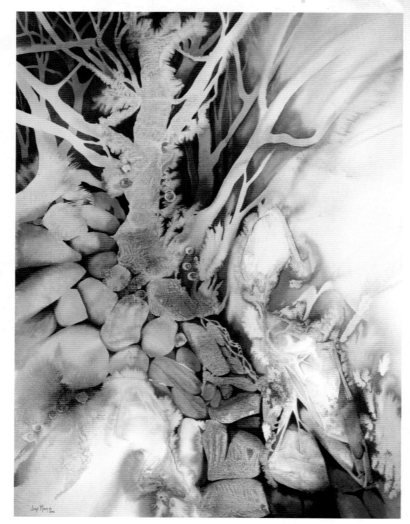

vertical shift

Rugged Territory wasn't originally vertical, but when I stepped back to consider the composition after applying the wet-into-wet layers, it made more sense in that format. Surgical gauze created the texture for the rocks and tree trunk.

● *Rugged Territory*
Watercolor on 140-lb. (300gsm) cold-pressed watercolor paper
30" × 22" (76cm × 56cm)
Collection of the artist

The hallmark of creative people is their mental flexibility ... Sometimes they are open and probing, at others they're playful and off-the-wall. At still other times, they're critical and fault finding. And finally they're doggedly persistent in striving to reach their goals.

—Roger von Oech

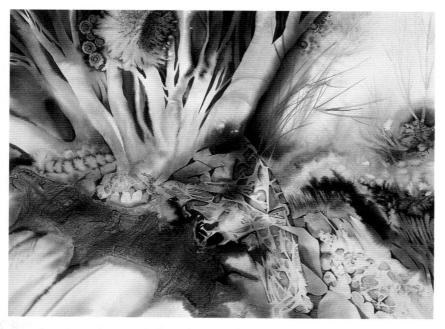

textural surprises

Indian Summer uses repeated forced bursts of water to create an edge of flowers behind the first clump of trees. The falling water was created by the wax paper texture, and the alcohol drops add interest in the tree foliage area.

● *Indian Summer*
Watercolor on 140-lb. (300gsm) cold-pressed watercolor paper
22" × 30" (56cm × 76cm)
Collection of the artist

painting in your community

Artists are always looking inside themselves to create new and interesting artwork. Sometimes it's refreshing to look outward by using your skills to benefit your community or a charity in need. I'm frequently asked to donate artwork for auction at a charity fund-raising event. Other times, I've offered myself up at the auction block! The highest bidder donates "me" to a local school where I present a full day of hands-on art projects for as many students as can be accommodated.

These experiences are great fun and allow me to give back to my community with what I love to do: create art and share it with others. The largest community project I was involved with took place in 2005. My hometown of Oshkosh, Wisconsin conducted a community public art project, The Pride of Oshkosh. Thirty-three life-sized lions were modeled after "Harris," one of the majestic bronze lions that flank the entrance to the Oshkosh Public Library. Artists from the community submitted proposals to transform the 8-foot (2m) long fiberglass replicas into a piece of artwork, which would then be auctioned off. The proceeds supported several local organizations.

I collaborated with fellow artist Joan Mosling on multiple designs. Our vision was to create one lion walking in Lake Winnebago and the other walking through a native Wisconsin prairie. We had seven months to complete the project.

Jorge was auctioned and sold for $13,000 and is in the media center at Treager Elementary School in Oshkosh. Jigs was auctioned for $18,000 and can be seen in the Paine Art Center and Garden's Family Discovery Center. It was an honor to work on this project. We're so glad that Jigs and Jorge remain in Oshkosh and continue to give to the community.

walking on the wild side

Jigs is walking through a native Wisconsin prairie. We painted native flowers such as cup plants, native grasses and purple coneflowers. Animal life is represented by rabbits, grass snakes and grasshoppers, as well as birds in nests and various insects. All native species are numbered, and the numbers correspond to a guide that identifies common and Latin names, presenting a wealth of educational information.

fur, fin and feather

Jorge is wading through a lake while all sorts of indigenous fish, including sturgeon, bass, bluegill, croppies and perch, swim by. A playful otter wraps around the lion's leg while a gull sits atop the fishing pole, which has caught a sheepshead. Water plant life is included, as well as water beetles, minnows and frogs at varying degrees of development.

working on jigs

Here Joanie Mosling and I are working on some of the flora and fauna. The transformation of both lions took seven months of work. Reconstructing the lion shape, working with fiberglass and using acrylic paint took both of us out of our comfort zones. It was worth the effort.

painting from
the imagination

Walk through an imaginary forest in your mind. Do you see a fresh day filled with soft light and sun-dappled meadows or dark, ominous, storm-filled skies with scary trees around every corner? Whatever you imagine can be developed if you're willing to be challenged by exploring the unknown. Open yourself up to the textural possibilities this chapter has to offer.

combine methods for mysterious effects

In this painting I used spider webbing to create intricate textures found in nature. I began by saving the white tree trunks by pressing masking tape with torn edges to the watercolor paper. The resulting effect feels spooky and mysterious.

● *Ghost Tree*
Watercolor and ink on 140-lb. (300gsm) cold-pressed watercolor paper
15" × 22" (38cm × 56cm)
Collection of the artist

What would life be if we had no courage to attempt anything?

—Vincent van Gogh

concepts & materials

Creating a unified painting is sometimes as simple as working with a specific set of colors. For this project, I decided to work with a triadic color scheme. This means I could choose any three colors that are equidistant from each other on the color wheel. Red, yellow and blue is the most common triad. A triad of secondary colors would use orange, violet and green. An intermediate color triad would be yellow-orange, red-violet and blue-green; or yellow-green, red-orange and blue-violet. For this project, I will use an intermediate color triad with the following pigments: Permanent Orange, Magenta and Green Blue. When these colors mingle, new colors and neutralization will result.

materials list

SURFACE
140-lb. (300gsm) cold-pressed watercolor paper

BRUSHES
1-inch (25mm) and 2-inch (51mm) flat
nos. 6 and 8 rounds

COLORS
Green Blue, Magenta, Permanent Orange

ADDITIONAL MATERIALS
spider webbing (available from craft and party supply stores), palette knife, masking fluid, rubber cement pick-up, masking tape, art board or Plexiglas, no. 2 pencil

triadic colors
I'll use Permanent Orange, Magenta and Green Blue for my intermediate color triad.

color combinations
Mixing this triadic color scheme can result in some great colors. Permanent Orange combined with Magenta can produce a range of colors from burnt orange to dark crimson. Permanent Orange combined with Green Blue creates soft, mossy greens. Magenta mixed with Green Blue creates a deep blue, as well as wonderful shades of purple. The amount of each pigment in the mixture determines the final result.

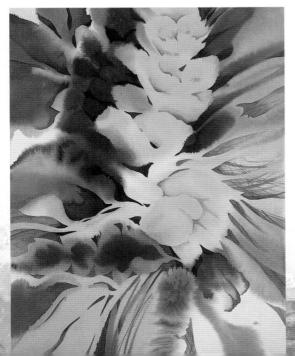

same triad color scheme
Autumn Flowers uses the intermediate color triad (Permanent Orange, Magenta and Green Blue) used in this demonstration. The painting looks quite different from *Fantasy Fig* (see page 101) because the colors were mixed before applying them to the paper. This creates a more subtle effect compared to the brighter results achieved from letting the colors mix on the paper, as you'll see in the demonstration.

● ***Autumn Flowers***
Watercolor on 140-lb. (300gsm) cold-pressed watercolor paper
15" × 11" (38cm × 28cm)
Private collection

painting with free-flowing color

Although you'll draw the composition, your initial paint application will set the tone for the entire painting. Begin with free-flowing color. If your colors are extremely dark, your painting will take on a spooky quality. If your colors dry lighter, your subject will seem more sunny and cheerful. Either result is fine. During the second half of the process, you'll interpret the new elements and modify the composition to enhance what the spider webbing created.

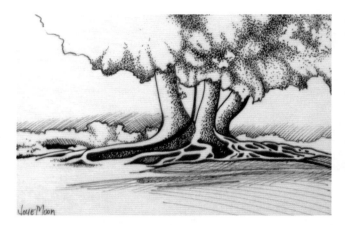

fascinating root structure
I quickly sketched this amazing tree at the Selby Gardens in Sarasota, Florida. I was fascinated by the aboveground root structure and hoped to incorporate it into a fantasy landscape. This thumbnail is just 4" × 5" (10cm × 13cm).

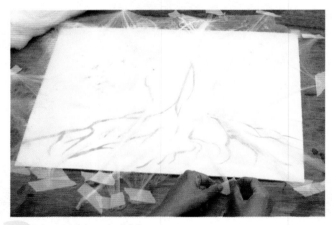

1 draw trees and mask highlights
Draw an outline for your tree shape. I did a simple line drawing of the fig tree on the grounds of the Selby Gardens in Sarasota, Florida. If you want to preserve highlights, use masking fluid to save the white of the paper. I saved the edge of some of the tree trunks by applying masking fluid with a palette knife. I also splattered masking fluid in the upper area of the tree. This will add a nice sundappled quality when the painting is complete.

2 position spider webbing
Cut a chunk of spider webbing from the main clump. The webbing can be thinned out by pulling it apart, making it sheer instead of thick and bulky. Place your composition on a sheet of Plexiglas or art board and tape the corners so it won't move. Position the spider webbing on top of your paper and pull out thin strips that can be taped to the outside of your composition. Do this while the paper is still dry so that the tape will be secured to the spider webbing.

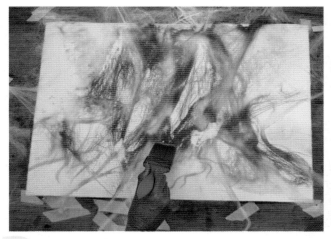

apply the first color

Wet the entire surface of the paper and spider webbing using the 2-inch (51mm) flat brush. Force water through the spider webbing to coat the watercolor paper below. Apply heavily saturated pigment onto the wet surface. This will dry lighter since it's being painted wet-into-wet. My color choice is Permanent Orange.

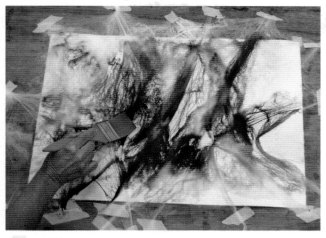

apply the second color

While still wet, continue to apply saturated color. My second color is Magenta. Force the color through the spider webbing with your brush (really load your brush with color). The color needs to be strong since it will be diluted by the wetness of the paper and spider webbing.

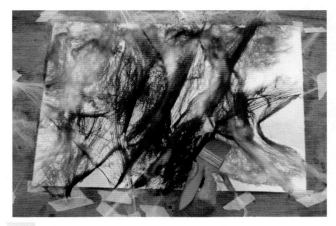

apply final color

Working quickly, apply your last color choice. Mine is Green Blue. The Green Blue commingles with the Permanent Orange and Magenta to create dreamy secondary colors, as well as neutralized combinations.

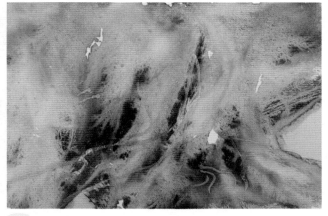

remove the spider webbing

Since the painting is extremely wet, the drying time will vary. I usually leave the spider webbing on overnight to be sure the watercolor paper underneath is completely dry. Notice how much lighter the colors are when dry.

The effort to see things without distortion takes something like courage and this courage is essential to the artist, who has to look at everything as though he saw it for the first time.

—Henri Matisse

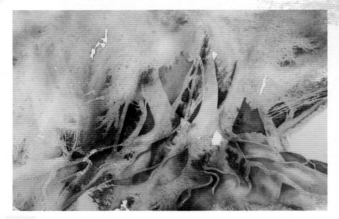

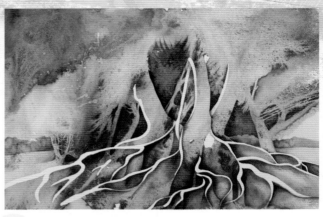

develop the tree shapes

You may have to redraw the initial tree so that you can see your composition. Find tree trunks and branches by painting the background area. You may need to replicate the spider webbing texture in certain areas if the transfer was spotty. I used the same three colors in varying values to paint the background.

establish the background

More trees may have appeared because of the spider webbing. Make these small background trees. Also, establish trees along the horizon boundary line. I removed the masking fluid from the tree trunk and the root system so I could develop these areas further. More texture was needed between the two tree trunks and the top left foliage area. I rewetted the paper in those areas and positioned a small amount of spider webbing. I then applied Green Blue, Magenta and a little more Permanent Orange and let the painting dry. These colors mingled to create a soft color area with new spider-web texture.

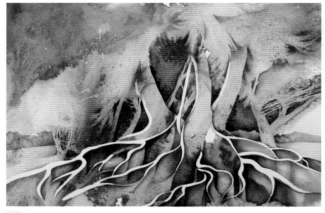

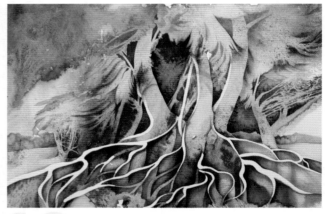

develop tree roots and foliage

Continue adding more detail to the tree trunk and roots by using the same three colors in deeper values. Add detail to the foliage, using the flow of the texture to guide your design.

push the values

Evaluate color placement and value changes. Keep pushing the values for depth and contrast. You'll notice that the foliage area is developing with a variety of designs and brushstrokes. Leaves and flowing strokes of paint appear to be blowing in the breeze

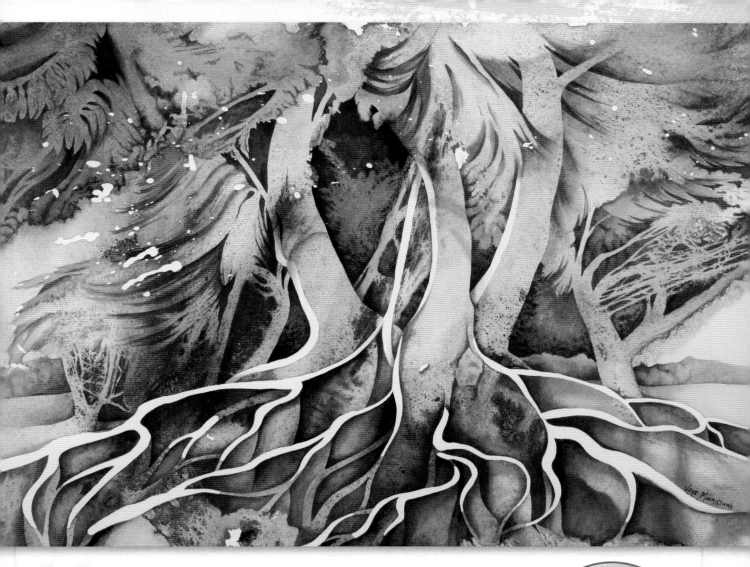

completed project

It's amazing how many different color combinations are generated by combining just three colors. I used negative painting techniques to capture the design of the tree shapes. The splattered masking fluid saved irregular white dots in the upper left portion of the painting. I continued to develop branches and leaves at the top of the fig tree. The results are fresh, interesting and fun.

● *Fantasy Fig*
 Watercolor on 140-lb. (300gsm) cold-pressed watercolor paper
 15" × 22" (38cm × 56cm)
 Collection of the artist

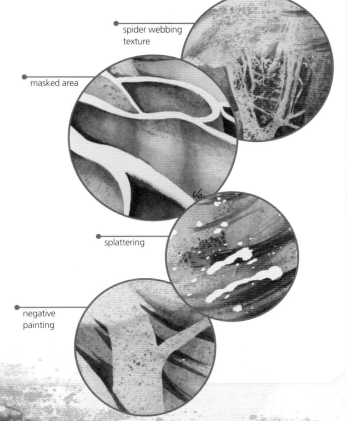

spider webbing texture

masked area

splattering

negative painting

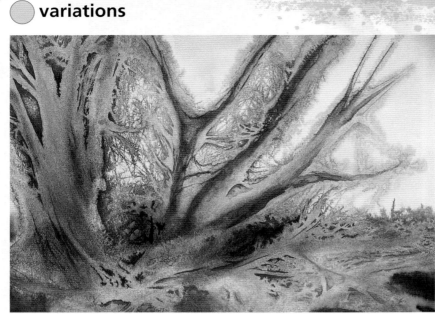

peaceful painting

I painted *Golden October* without any color in the sky area. Since the paper was completely wet, soft color moved into that space. I successfully achieved a soft, peaceful quality in this painting.

● *Golden October*
Watercolor on 140-lb. (300gsm) cold-pressed watercolor paper
15" × 22" (38cm × 56cm)
Collection of the artist

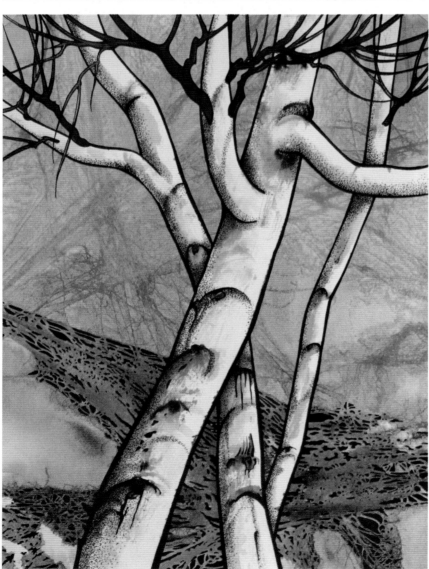

abstract background

Birch Stand was developed using masking tape to save the white of the paper for the birch trees. I could safely paint the background using the spider webbing as an abstract texture. When it dried, I removed the tape to finish the white birch trees. I also used a black pen to detail the trees and reinforce the design of the spider webbing in the background.

● *Birch Stand*
Watercolor and ink on 140-lb. (300gsm) cold-pressed watercolor paper
15" × 11" (38cm × 28cm)
Collection of the artist

re-surfacing your techniques
transferring techniques on yupo

You can use a variety of materials to transfer paint to a surface. Instead of spider webbing and traditional paper, why not try bubble wrap and Yupo paper?

Yupo paper is 100 percent synthetic, acid-free and archival. It's available in different weights ranging from 68-lb. (143gsm) to 144-lb. (302gsm), as well as different sizes. Yupo isn't absorbent, so you have lots of time to play with paint on it because the only way the paint dries is by evaporation. If you don't like the completed artwork, you can rinse off the paint (though staining colors might leave a thin veil of color). All the techniques you've learned still work—from alcohol drops to salt, from pouring paint to brushing it on—but they look completely different on Yupo.

1 *add salt and alcohol for texture*
Begin by dipping a cotton ball in isopropyl alcohol. Squeeze out the excess alcohol and rub the cotton ball over the surface. This removes the outer coating and gives the surface a bit of tooth to better accept the paint.

Apply Tiziano Red and Burnt Sienna. While the paint is wet, sprinkle table salt strategically on the surface. (Salt reacts nicely on the Yupo.) Drop isopropyl alcohol from an eyedropper for a unique compositional element.

2 *apply bubble wrap*
Apply fresh water with the 2-inch (51mm) flat brush. Since the water has to evaporate to dry, you'll have plenty of time to play with color. Add Tiziano Red, Burnt Sienna and Primary Blue and let the paint explode into the wet surface. Position the bubble wrap to create a design. You can add paint around the bubble wrap if more color is needed to emphasize the design.

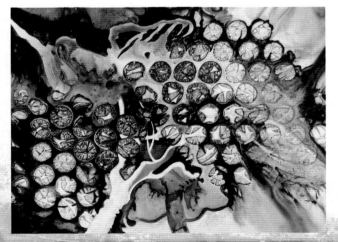

3 *remove the bubble wrap*
When the paint is dry, remove the bubble wrap. You can keep all the bubbles or eliminate some by painting over them.

Notice the vibrancy of the color on the Yupo paper. Since the paint isn't absorbed into the surface, the colors stay rich and juicy. I enjoy working abstractly on Yupo paper, but it can also be used for impressionistic landscapes and florals.

● *Breezy Apple Tree*
Watercolor on 144-lb. (302gsm) Yupo paper
11" × 15" (28cm × 38cm)
Collection of the artist

Joye Moon ©

painting
the garden

A painting subject begins as a tiny idea that forms in the depths of our subconscious. The artist's responsibility is to search out those ideas and bring them to completion. Sometimes a paintable subject is right in front of us and we only need to view it with fresh eyes to reinvent the end result. You can alter ordinary painting methods with a subtle twist of the wrist or by sculpting away paint with a palette knife. Trust your instincts and your inner voice as you embark on the creative process.

color and lighting depict weather conditions

Roses at Isola Bella, Stressa, Italy is a painting of a summer day in a multi-level garden located on an island in a huge lake in northern Italy. The heat of the day is indicated by the warm coral sky. This color is also reflected in the flowers sitting on the stone wall. The cast shadows add to the intense lighting effect, giving the viewer a good idea of the weather conditions.

● *Roses at Isola Bella, Stressa, Italy*
Watercolor on 140-lb. (300gsm) cold-pressed watercolor paper
7" × 15" (18cm × 38cm)
Collection of the artist

If the painter has a good sense for the feeling that is to be conveyed in the painting, it will be easy to select the right texture to work with it.

—Stephen Quiller

concepts & materials

challenging greens

Many artists confess that painting with greens can be challenging. Generally, green paint straight from the tube doesn't look like most greens seen in nature. These pigments tend to be too bright and unnatural. Combining a tube green with any other color will create interesting greens. Adding warmer colors, such as various yellows, oranges and reds, will create warm greens. Adding cooler colors, such as blues and violets will create cool greens that will also recede.

handling a craft knife and razor blade

A craft knife is handy for removing color from and adding texture to a surface. Hold the craft knife as if you are holding a pencil. Gently scrape off the top layer of paint, scraping deeper to get to the white of the paper. 140-lb. (300gsm) paper can be scraped quite a bit without cutting through the paper. Use a razor blade in the same manner. I prefer to use a one-sided razor blade for safety. Hold it between your thumb and index finger to scrape away paint and paper.

materials list

SURFACE
140-lb. (300gsm) cold-pressed watercolor paper

BRUSHES
nos. 6 and 8 rounds

COLORS
Burnt Sienna, Cerulean Blue, Cupric Green Deep, Gray, Indanthrene Blue, Magenta, Naples Yellow, Primary Yellow, Quinacridone Gold, Stil de Grain Brown, Sandal Red

ADDITIONAL MATERIALS
palette knife, masking fluid, rubber cement pick-up, twine, razor blade or craft knife, pencil

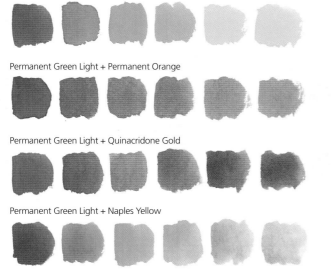

Permanent Green Light + Primary Yellow

Permanent Green Light + Permanent Orange

Permanent Green Light + Quinacridone Gold

Permanent Green Light + Naples Yellow

Cupric Green Deep + Permanent Red Light

Cupric Green Deep + Sandal Red

Cupric Green Deep + Primary Yellow

Cupric Green Deep + Ultramarine Blue Deep

Cupric Green Deep + Quinacridone Gold

pleasing greens
Combine green paint with other colors to create interesting, natural greens.

more green combinations
Here you can see some of the beautiful, natural-looking mixtures that result from combining green with other colors.

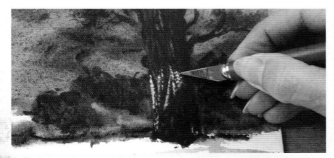
Correct craft knife positioning

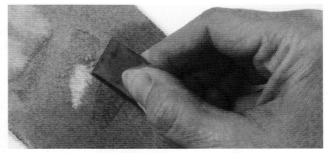
Proper razor blade handling

sculpting flowers using a palette knife

Years ago, I invited artist Diane Maxey to present a one-day workshop for my art students. Her demonstration showcased a method for using the palette knife to develop flowers. With her permission, I pass along this technique, modified for my painting style. Thank you, Diane, for this fun, fresh way to create flowers.

So far, we've used the palette knife to apply masking fluid, scrape away texture from tree bark, and apply paint for twigs and branches. This project uses the palette knife to sculpt a variety of flower shapes and to develop natural-looking grasses. This is a quick and easy way to create lively flowers in the distance. We'll also use twine to create a textured design in the walkway.

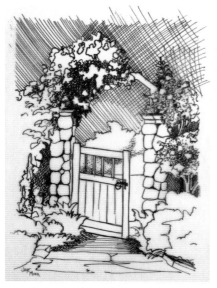

composing from the imagination
I envisioned creating a landscape that had a gate, trellis and lots of flowers. I just started doodling and came up with this 5" × 4" (13cm × 10cm) composition.

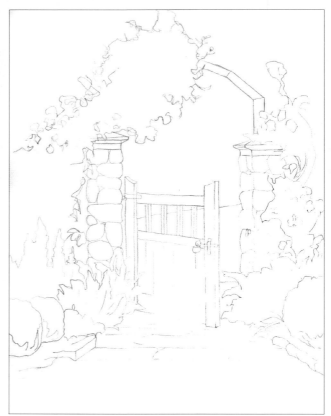

draw the composition
Draw the composition with a sharp pencil. Outline only where you want the clumps of flowers to be located. Don't draw in each flower—that's working too hard!

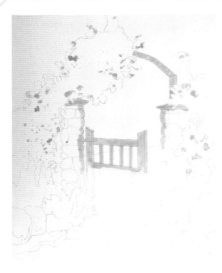

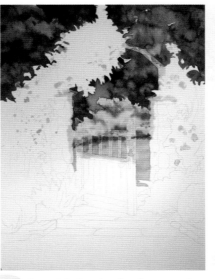

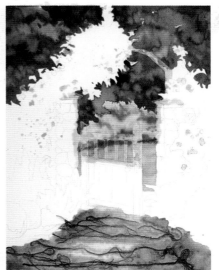

mask the whites

Using a palette knife, apply masking fluid where you want to save the white of the paper. These areas can be painted in later if necessary.

paint wet-into-dry background and force a burst

Since there's a large background area to cover, paint only a small portion at a time, stopping to force a burst of water and then continuing. Using a no. 8 round, apply a variety of richly saturated pigments, like Indanthrene Blue, Cupric Green and Quinacridone Gold. Drop fresh water from the end of the brush to force a burst and create texture in the background. The paint color will remain strong since it's been painted on a dry surface.

use twine to texture

Wet the walkway with water and position the unraveled twine somewhat horizontally. Using a no. 8 round, apply a thinned mixture of Primary Yellow and Stil de Grain Brown.

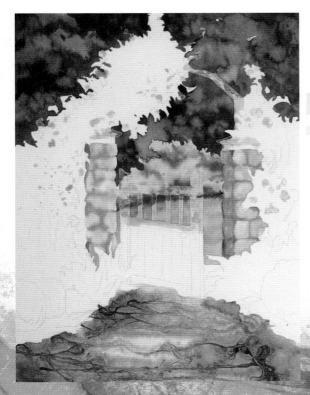

paint the stone pillars

Using the wet-into-wet method, lay the foundation color for the stone pillars with the no. 8 round brush. Switch to the no. 6 round if you need a smaller brush to fit into tiny areas. While this is still wet, use the triangle method (see the "Painting Rocks" Mini Demonstration on page 92) to form the rocks that make up the pillars.

When the walkway is dry, remove the twine. The delicate texture will make an interesting pattern for the beginning of the stone walkway.

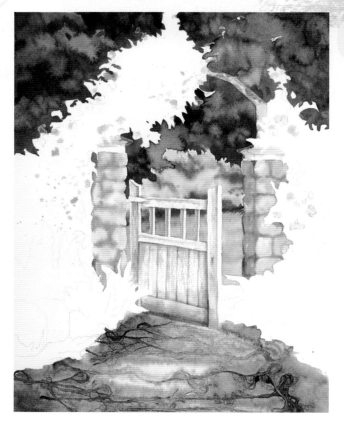

paint the gate

Remove the masking fluid from the gate. Paint wet-into-wet to vary the gradation of the weathered wood. As it dries, add detail to differentiate the design of the wood slats. Let the door dry completely and drybrush for added texture, using a no. 6 round and Cerulean Blue, Burnt Sienna and Gray. Later, you can complete the detail and use a razor blade or craft knife to scrape away color for added white.

mini demonstration

flower clumps

Flowers shown at a distance don't have to be painted with precision, ensuring that the viewer understands the composition. Sometimes, suggesting clumps of flowers by creating simple shapes makes enough of a statement to get your idea across. You can create a variety of flowers, such as hanging roses, petunias, hollyhocks, salvia and daisies by using the palette knife technique. You can enhance grasses using this technique as well.

1 Use the no. 8 round brush to apply dabs of color. It's OK to leave some white paper showing. I also added a tiny amount of green to represent leaves.

2 Before this dries, use the palette knife to round out some color for added texture and dimension. Work quickly while the paint is still wet and moveable.

3 When the flower clump is dry, add another value to reinforce the sculpture. You can paint more leaves and shadows on the bottom and along the shadow edge to give the illusion of depth. I like to use a bright color like Cerulean Blue for a shadow rather than a dull gray.

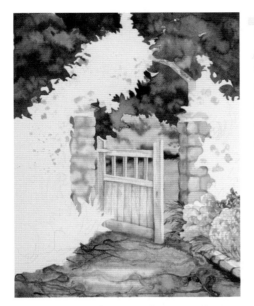

paint the flowers

Using the no. 8 round, paint one flower clump at a time so you can sculpt it with the palette knife at the optimum drying moment. Follow the sculpting method in the mini demonstration on the previous page. These flower areas can represent mum-like plants. I used a combination of Naples Yellow and Quinacridone Gold for the yellow flowers and Sandal Red for the red flower clumps. I combined Cupric Green with Primary Yellow and Quinacridone Gold to create a nice variety of greens. After using the no. 6 round brush to apply strokes of paint for the grass areas, use the palette knife to manipulate the paint into grass shapes.

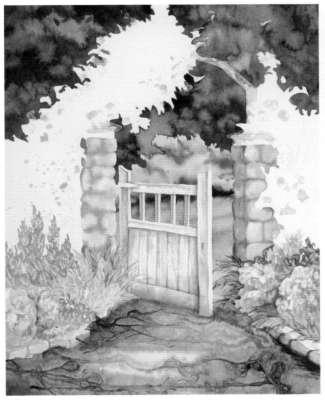

add more flowers and grasses

Using the colors from Step 7, paint the grasses with the same sculpting method, but keep the palette strokes long and irregular to indicate tall ornamental grasses.

Continue to add variety of texture to your garden by including tall spiky flowers such as salvia or lupines using Indanthrene Blue and Cerulean Blue. Ferns can take on a mossy green color and add variety to the garden. I used a combination of Cupric Green and Naples Yellow to create them.

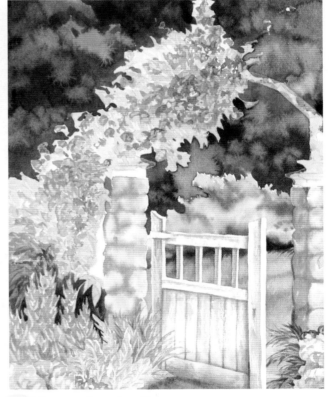

add the overhanging flowers

Since this is a large grouping of blossoms, you'll need to work quickly, completing one section at a time. Apply Magenta at the top and quickly sculpt with the palette knife. Continue down the overhang of flowers by applying more paint and quickly sculpting. Continue to move down the flower area until completed. Remember to add a variety of colors such as Magenta and violet (a mixture of Indanthrene Blue and Magenta) including some greens for leaves.

remove masking fluid and deepen values

When the painting is completely dry, remove the masking fluid with the rubber cement pick-up. Feel the paper surface to make sure you have removed all the masking fluid. Consider your light source and drop some color into the shadow areas. I like to use Cerulean Blue for shadows to create the look of a sunny day.

Garden Entrance explores a variety of textures found in a flower garden. Painting in this manner is like building a patchwork quilt. You paint a bit at a time, choosing color combinations, various patterns and different stokes of texture to invent your own imaginary garden. The best aspect of this painted garden is that weeds don't grow!

● *Garden Entrance*
Watercolor on 140-lb. (300gsm) cold-pressed watercolor paper
15" × 11" (38cm × 28cm)
Collection of the artist

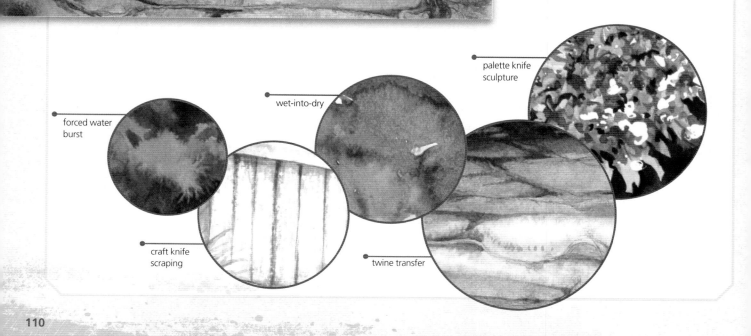

forced water burst

wet-into-dry

palette knife sculpture

craft knife scraping

twine transfer

variations

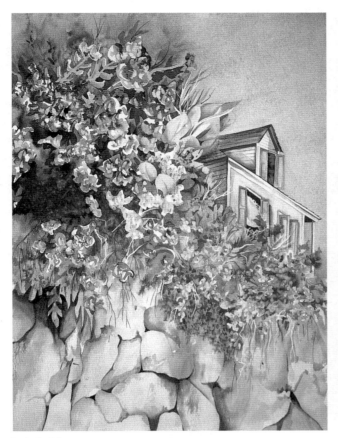

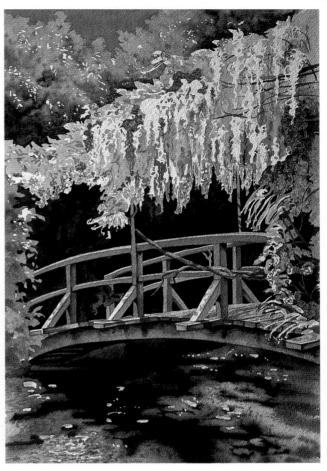

bright blossoms

I painted *Bahamian Breeze* on the island of Eleuthera, in the Bahamas. The huge bougainvillea was bright and colorful in the sunshine and even matched the roof of the house in the background. Using a palette knife to create the bougainvillea worked perfectly.

• *Bahamian Breeze*
 Watercolor on 140-lb. (300gsm) cold-pressed watercolor paper
 15" × 11" (38cm × 28cm)
 Collection of Peggy Frank

rich greens and textures

Monet's Garden is a painting of Monet's famous bridge with hanging wisteria vines. The blossoms were drenched with sunshine. The painting illustrates the variety of greenery in Monet's garden, as well as the textures of the different flowers types. I used the palette knife and saved the whites of the flowers with masking fluid.

• *Monet's Garden*
 Watercolor on 140-lb. (300gsm) cold-pressed watercolor paper
 11" × 8" (28cm × 20cm)
 Private collection

Art is like a jealous mistress. It will take any time you can give it and any time it can steal.

—Paul Donhauser

CHAPTER 12

painting
people

Years ago, I thought I needed a new artistic challenge, so I
delved into painting portraits—not just painting faces, but
portraying the entire body from different angles and perspec-
tives. I wanted to place the figure in imaginary environments
with colors that would entice the viewer. I incorporated many
textural methods within the figure itself or the background.
Finally, I used the body as an element of composition to move
the viewer's eye through the painting.

 This challenge took me from painting traditional portraits
to painting very complex compositions like the one featured
in this chapter.

color creates impact
Golden Memories is a painting of my
daughter, Rachel. The background is
completely imaginary and made up. I
chose the color combinations quite care-
fully for maximum impact and created
backlight in the tree area to softly lose
the edges of the branches.

● *Golden Memories*
 Watercolor on 140-lb. (300gsm) cold-pressed
 watercolor paper
 22" × 30" (56cm × 76cm)
 Collection of the artist

Whatever you can do, or dream you can,
begin it. Boldness has genius, power and
magic in it.

—Johann Wolfgang von Goethe

concepts & materials

lighting

Try to think creatively when considering the lighting scheme for portrait work. The light source can enter from any direction. It can also be subtle or strong—no way is right or wrong. Just make sure the viewer has a good sense of where the lighting is coming from.

composition

I want anything but a conventional portrait composition in my work. Strive for interesting angels and perspectives while using the entire body or closeups of the head and shoulders.

materials

To keep you moving along on this textural journey, I'll incorporate coffee filters, aluminum foil and an abrasive eraser to create a variety of new textures. The aluminum foil will create a random texture behind the figure, the coffee filters will start the curve of the wicker chair and the abrasive eraser will lift color from the pillow area.

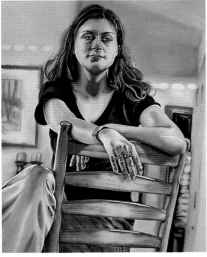

● *Lit From North and South*
Watercolor and casein on 140-lb. (300gsm)
cold-pressed watercolor paper
30" × 22" (76cm × 56cm)
Collection of the artist

shift the focus

This painting breaks the rule of not placing an object in the center of the composition. Although the figure is positioned somewhat in the middle, the background spatial changes help take the focus off the central positioning. I painted several walls, angled the doorways and used contrasting lighting in the room farthest back to enhance the composition. I used a craft knife to scrape oval shapes of sunshine across the walls behind the figure. The sunshine wasn't actually there, but I thought it would create an interesting design element in the background.

materials list

SURFACE

140-lb. (300gsm) cold-pressed watercolor paper, 15" × 20" (38cm × 51cm)

BRUSHES

1-inch (25mm), 1½-inch (38mm) and 2-inch (51mm) flats

nos. 6 and 8 rounds

COLORS

Burnt Sienna, Cerulean Blue, Dragon's Blood, Garnet Lake, Green Blue, Indanthrene Blue, Naples Yellow, Permanent Orange, Permanent Violet Bluish, Tiziano Red, Quinacridone Gold, Stil de Grain Brown

ADDITIONAL MATERIALS

graphite paper, full-size photocopy of reference photo, red fine-point pen, kneaded eraser, abrasive eraser, aluminum foil, coffee filters, palette knife, masking fluid, rubber cement pick-up, no. 2 pencil

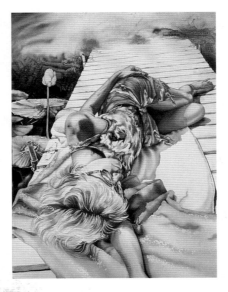

draw in the viewer

I strategically positioned the figure on this imaginary dock over water for maximum compositional impact. I tipped the dock to the left a bit for a spatial tilt. The bright lime green towel and the arm reaching beyond the picture plane invite you into the scene. The viewer's eye is moved to the head, through the torso and beyond to the foreshortened leg. From there, the eye moves along the right edge of the dock, along the top and back down the left side of the dock, along the yellow lotus blossom and back into the figure.

● *Dreaming in Color*
Watercolor on 140-lb. (300gsm) cold-pressed watercolor paper
30" × 22" (76cm × 56cm)
Collection of the artist

● ● ● **demonstration**

painting a portrait

Painting a portrait is no different than painting a flower. There are curves and contours, translucencies and dark shadows. Veins and lines make up both face and flower. You can be as realistic as you like or only paint the basics and leave out all the "bags and sags." When painting a portrait of myself, I enjoy adding cleavage! Don't be afraid of this portrait project. We're all on a learning journey and this project will move you further along your artistic path.

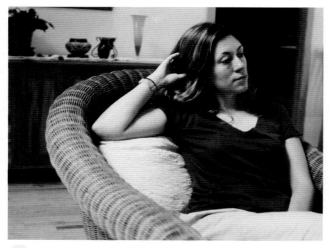

1 evaluate your reference photo

If you're working from a photograph, you'll need to evaluate the composition. I use photos only to generate ideas—I don't try to copy them. Consider doing something completely different with the background or the lighting effects. Change the color of the subject's clothes and hair, or crop in tightly for a close-up of the face. Play with the photo to make it more interesting as a painting.

preliminary sketches

Doing a quick pencil or ink sketch of the subject before starting a painting serves five purposes.

1. It helps you become familiar with the subject.
2. You can play around with positioning the subject, and determine the paper size you'll need.
3. A sketch helps you determine what elements of the composition are important and what can be left out.
4. You can decide the lighting direction and effects you want to explore.
5. You can play around with background ideas.

All in all, a preliminary sketch is useful with any subject such as landscape, seascape, still life, floral or portrait.

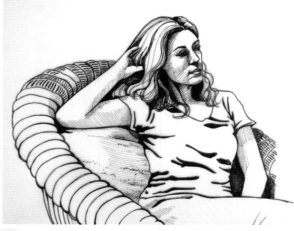

2 sketch the composition

Sketch your composition, incorporating the parts of the reference photo you plan to use. This photo of my daughter, Rachel, had a round composition that I liked. The vantage point is from slightly below, forcing the viewer to look up at her. I brought those elements into play in the sketch, and took out the background to simplify the composition.

To make your first portrait project easier, draw the face large. The head, not including the hair, should be drawn at least as large as the size of your entire hand. The larger you draw the face, the more space you have to play with different colors and develop the different planes of the face. It will also be easier to paint elements of the face if it's large.

Demonstration continues on page 116.

transferring an image

In my own work, I just "go for it" and draw the subject with a sharp pencil. But I've had years of practice with realistic figure drawing, and have drawn skeletal studies from every conceivable angle. Since my students have varying levels of drawing ability, I encourage them to try to transfer compositions using graphite paper. This method ensures a more accurate drawing. Even the Old Masters used grid methods to transfer images, so don't think you're cheating by using this transfer method.

materials list

red fine-point pen, graphite paper, photocopy of reference photo, masking tape, watercolor paper, kneaded eraser, no. 2 pencil

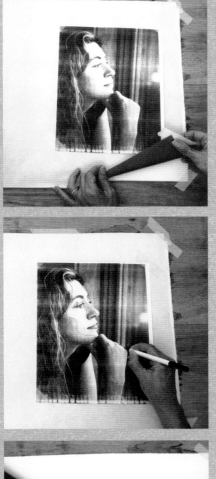

1 Make a black-and-white photocopy of your photo scaled to the exact size you want it on your paper. To ease the tracing, don't copy onto thick paper. Secure the watercolor paper to a board with masking tape. Put the graphite paper—graphite side down—on top of the watercolor paper and secure it with tape. Place your photocopy on top of the graphite paper and tape it into position. Make sure none of the elements shift.

2 Using a fine-point pen with red ink, trace the outline of your image, including where the shadow areas begin and end. The red ink makes what you've already traced obvious, and the fine point of the pen transfers the right amount of graphite. Don't be too heavy-handed—graphite lines are difficult to erase, and you can alway touch up the drawing afterward with a no. 2 pencil.

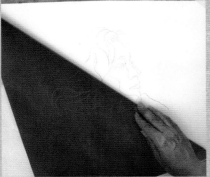

3 Early in the tracing process, carefully pick up the photocopy and graphite paper at the same time to see if the pen pressure is too heavy or too light. Continue to trace any elements you want in the composition.

Remove the photocopy and the graphite paper. You may need to lift some graphite using a kneaded eraser if it's too dark. You can add more line work with a pencil if it's too light.

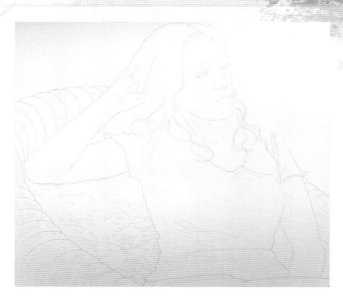

draw the composition

If you're not using the graphite transfer method, use a very sharp no. 2 pencil to draw the composition onto the watercolor paper. I like my drawing to consist of one continuous line rather than a lot of sketchy lines. You need to know exactly where to place the paint. The sharper your drawing, the more exact your portrait will be. Notice that I've indicated where the shadows should be placed and the highlights positioned.

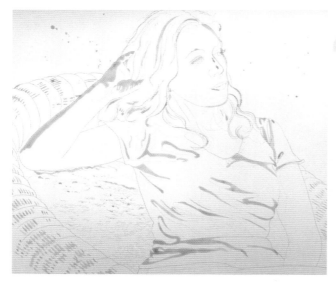

mask the highlights

Using the palette knife, apply masking fluid to save the white of the paper for highlights, as well as the edge of the face if needed. This area can be painted after the background is complete. Note the design of the masking fluid shapes. There aren't any ragged shapes. Each shape is clear and concise and can be developed later into passages with interesting shapes that reinforce the design elements of the lighting effects.

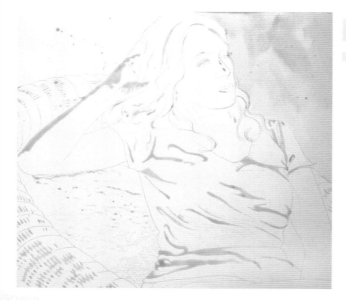

paint the background wet-into-wet

Begin by painting the background. It's easier to add the figure later, and the edges will stay sharp. The background can be altered later if needed.

I wanted an intriguing yet subtle area behind the figure, so I combined wet-into-wet painting with an aluminum foil transfer to add a lightly textured background. To do this, start painting the background wet-into-wet. Apply water to the entire background with the 2-inch (51mm) flat brush, then apply your pigment. I applied Naples Yellow.

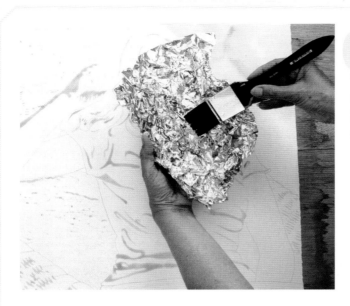

apply paint to aluminum foil

While the paint dries, crumble up the aluminum foil then apply paint to the surface of the foil. I used a combination of Naples Yellow and Burnt Sienna. I chose these colors because they are from the warm color family and will contrast nicely with the violet shirt that will be painted later.

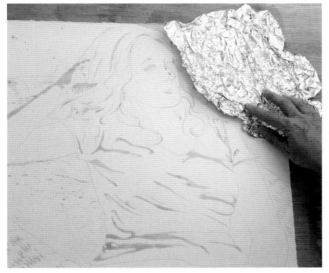

transfer the paint

Press the painted foil onto the background area and let it dry completely before removing. You may want to put a small weight on top of the foil to hold it in position. Where the background area is dry, the transfer will be more distinct. Where it's still damp, the transfer will have softer edges.

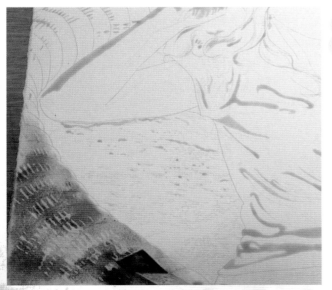

lay a wet-into-wet wash on the wicker chair

I used coffee filters as the pattern for the wicker chair to give an impression of wicker without having to paint every detail. Start by painting wet-into-wet with the 1½-inch (38mm) flat. I applied Dragon's Blood and added Burnt Sienna in areas for variation. I thinned values of the same colors for highlights on the arms of the chair. These colors are rich and work well with the background colors.

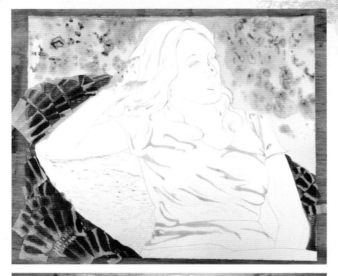

apply coffee filters

While the paint is still wet, place pieces of torn coffee filter on the chair arm. Position them in the same direction as the fold of the chair arm. The coffee filters are absorbent and will lift pigment. You might need to add more paint while wet or just water for a subtle look. I kept feeding in color under the coffee filter pieces to get a rich color transfer. The coffee filters create subtle shapes where the color is absorbed.

As this dries, complete the background using the wet-into-wet method and aluminum foil transfer.

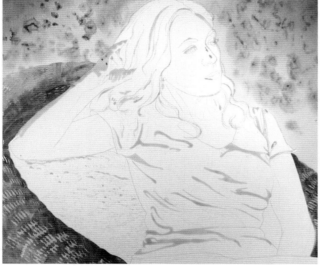

remove coffee filters

When everything is dry, remove the coffee filters. At this stage, the coffee filter transfer doesn't look very exciting.

back to front

I paint a portrait the same as I would paint a landscape or a still life. I always paint from the background to the foreground. The subject gets painted last. For instance, you wouldn't paint the trees before the sky. It's too difficult to add the sky behind tiny branches once the tree is complete. Therefore, we will paint the entire background in before starting the figure.

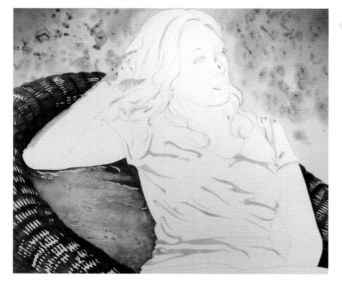

complete the wicker chair and pillow

Detail the chair as needed. Don't forget to develop the shadows needed for contrast. I added Quinacridone Gold, Stil de Grain Brown and Permanent Violet Blueish for the darkest value in the shadow. Apply the paint one color at a time, wet-into-wet, with a no. 8 round. Use a no. 6 round for tighter locations and details. Remove the masking fluid with the rubber cement pick-up when the chair is completed.

Since you should complete as much of the background as possible before starting the figure, this is a good time to begin painting the pillow. I used the wet-into-wet method with the 1-inch (25mm) flat. My color choices were mixtures of Burnt Sienna, Indanthrene Blue and Permanent Violet Blueish. I applied strokes of color with the no. 6 round for depth of color when depicting the texture of the pillow. It looks a bit dark at this stage, but I'll use an abrasive eraser to take away color later.

start painting the figure

Now that the background is complete, focus on the portrait portion. Using the wet-into-wet method, apply clean water to the face and neck area using the 1-inch (25mm) flat brush. Build the planes of the face with Naples Yellow. While that's still wet, add darker colors such as Tiziano Red, Stil de Grain Brown and Permanent Orange for contouring. Let the base color float into the hair area for a smooth transition between the face and hair. Using the same colors as in the face and neck, paint the rest of the exposed skin. Keep in mind the curve of the arms, shadow areas and other lighting effects. Work quickly to blend the colors before these areas dry. We will add more layers of color to finetune the flesh areas, so don't rush the painting process.

Demonstration continues on page 120.

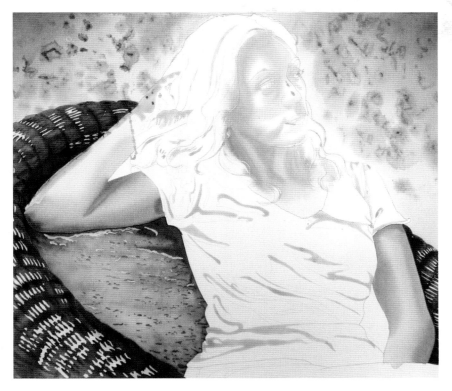

background balance

There are a variety of hard and soft edges in the background at this point, which I like, but it's a bit stronger than I intended. I may glaze color over this later to push it farther back where it won't compete with the subject for attention.

mini demonstration

painting facial structure

Bone structure and muscle create the multifaceted angles of the human face. This diagram shows the directions of the facial planes. Nothing is flat. Each element, such as the eye, has two curves: rounding from the top lid to bottom lid, and from the inside of the eye to the outside of the eye. Keep in mind the variety of angles that make up the face and paint your brushstrokes in those directions.

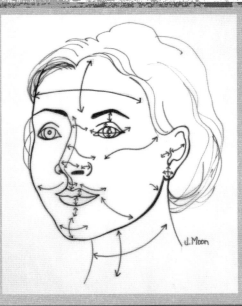

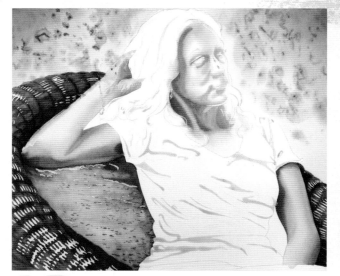

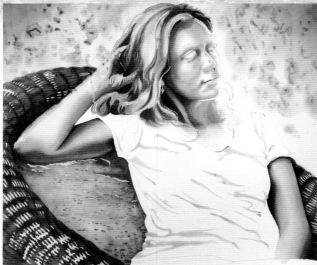

add another glaze

Rewet the face and neck and apply another glaze of the colors used in Step 12. Use this application to develop depth around the eye and define the shadows. You may have to switch to a no. 8 round to get into some of the tight areas. Apply another glaze to the arms.

continue developing the face, arms and hair

Rewet the face and neck area and apply the final paint for contouring. At this point, you want to accentuate the darks for a dramatic effect. While the face is drying, start painting the hair area wet-into-wet. Lift color with a thirsty brush to add to the variety in the hair and add movement and waves if needed. Complete contouring the arms with a final glaze of color.

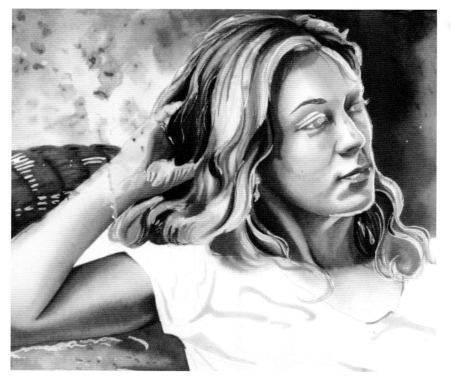

detail the face

At this point, you can safely paint the details of the face. (But don't remove the masking fluid yet.) Use a no. 6 or no. 8 round for the tiny details. This close-up of the face shows the variation of color that defines the eyes and makes them appear round as well as recessed into the eye socket. Simplify whenever you can. Notice how color, shadow and the direction of the brushstroke create the volume needed to convey the planes of the face.

Add a darker color to the background behind the face for contrast. I used a mixture of Permanent Violet Blueish and Stil de Grain Brown.

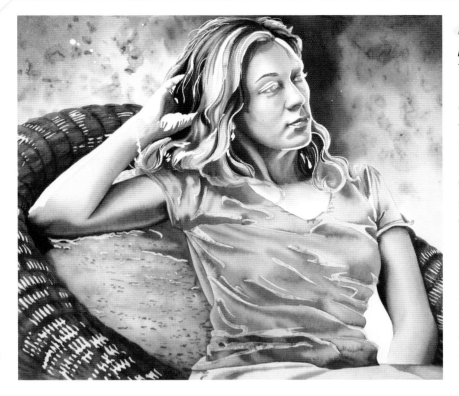

remove masking fluid and begin painting the clothing

Try not to overwork the face area. Lifting color from the face can lead to dullness. Remove the masking fluid from the face, hair and arms with a rubber cement pick-up when all the paint is dry. You may need to soften the edges of or add color to the saved white areas to complete the flesh areas.

The whites of the eyes should never be the white of the paper. Keep in mind there is a shadow cast from the eyelashes and overhang of the eyebrows that would cause the white of the eyes to be a bit darker than the white of the paper.

Using the wet-into-wet method, begin painting the shirt. Apply clean water, then start with thin color and work to darker colors to contour the drape of the fabric. I used a 1-inch (25mm) flat brush with Permanent Violet Blueish and Indanthrene Blue.

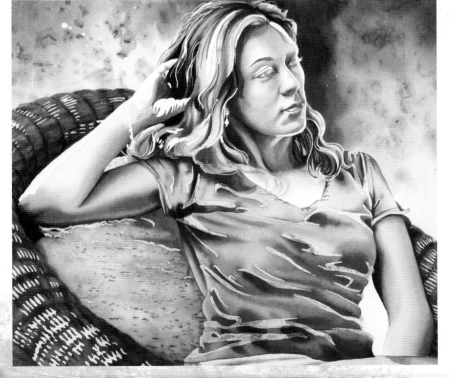

apply second glaze to clothing

If the color doesn't seem strong enough after it dries, strengthen it with another layer of wet-into-wet color. Continue to emphasize the contours. Because Permanent Violet Blueish and Indanthrene Blue are dark colors, you can use them to tidy up the edges of the arms or the background that meets the clothing. Develop the fabrics with techniques such as forcing a burst of water or lifting color for subtle highlights.

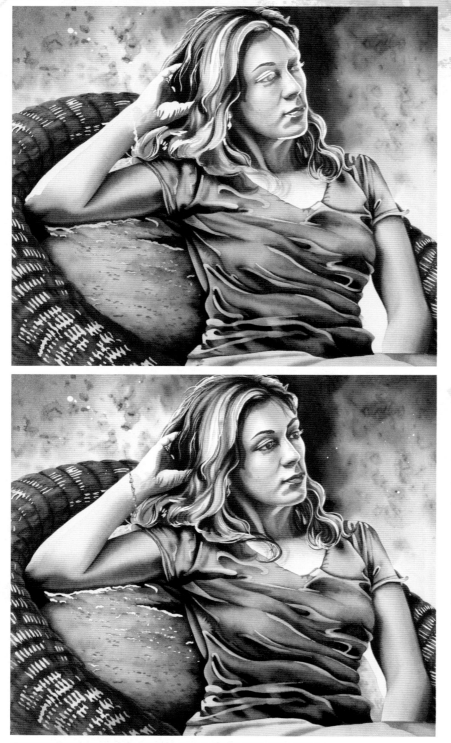

complete the clothing

When this area is dry, remove the masking fluid. Study the subtle folds and drape of the fabric that creates the volume. Shadows are important as you develop the clothing. The garment should appear to hug the figure underneath and follow the contours of the body.

add finishing touches to the figure

Add any remaining details to the face. Fine-tune the shadows and check value changes for clarity. If your subject has hands or feet, detail them as you did the face. I used a mixture of Green Blue and Cerulean Blue for the bracelet and earring. I chose this combination for a cool color note against the warmth of the chair color and Rachel's warm skin and hair tones.

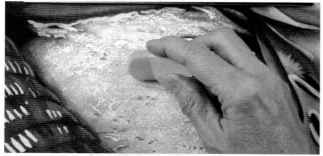

An abrasive eraser can take away bold color and gradate color with little pressure.

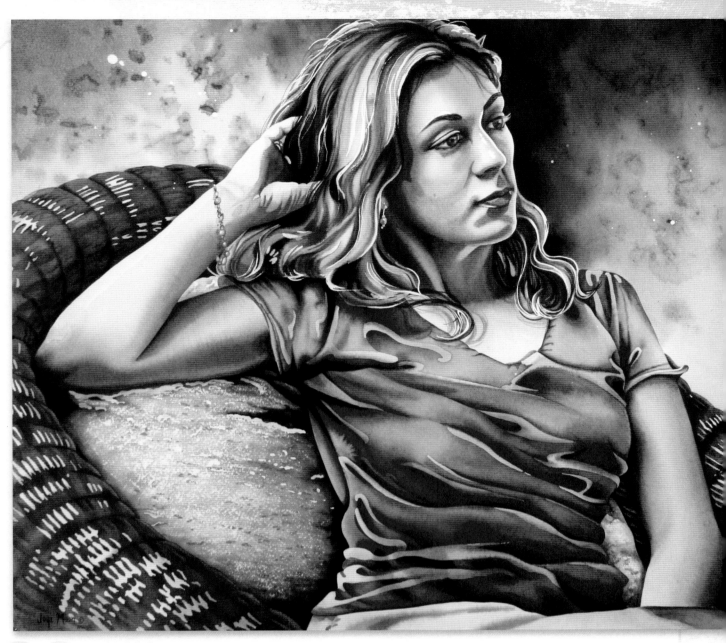

erase to create highlights

I left the pillow highlights last because I wanted to see how the other values developed in the composition. Using an abrasive eraser, I erased where I needed the pillow to be lighter. Although there was plenty of volume to the pillow, I thought there should be more direct light in that area. Using an abrasive eraser is an excellent way to take away color in a controlled manner. The pillow now has more of a sun-dappled quality.

Looking at the Lake started with a realistic photo but took on a more creative quality by simplifying elements and using different texture methods for variety.

● *Looking at the Lake*
 Watercolor on 140-lb. (300gsm) cold-pressed watercolor paper
 17" × 19" (43cm × 48cm)
 Collection of the artist

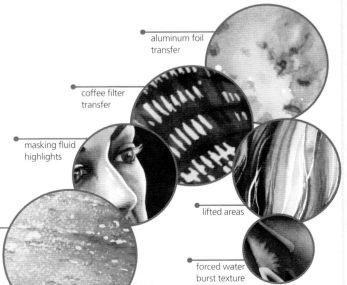

aluminum foil transfer

coffee filter transfer

masking fluid highlights

lifted areas

abrasive eraser

forced water burst texture

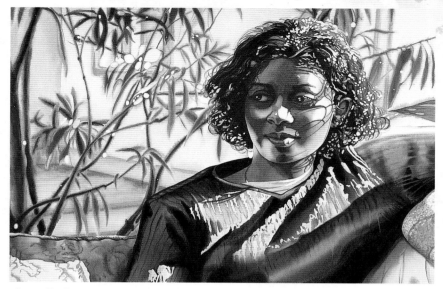

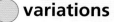

● *Karen*
Watercolor on 140-lb. (300gsm) cold-pressed
watercolor paper
15" × 22" (38cm × 56cm)
Collection of the artist

play of light

The model for *Karen* is my beautiful daughter-in-law. This
painting has been exhibited at many national and international
exhibits, winning many awards. Notice the beautiful shadows
across her face. The intense light streaming in from the window
created a dramatic play of light.

I began the painting by saving the sparkles of light in Karen's
hair and face with masking fluid. I also saved the highlights on
her sweater and the sun-dappled areas of the potted oleander
tree. I was very conscious of the warm and cool balance of
color in the painting, as well as the juxtaposition of background
light and the darkness of the figure. To diffuse and push back
the background, I created soft edges on the tree, flooring and
window by using the wet-into-wet method. Using sharp edges
for Karen brought the figure forward and helped separate her
from the busy background.

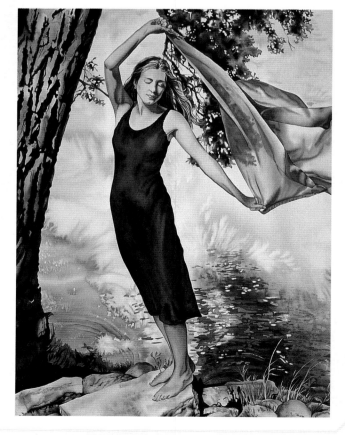

taking liberties

I had fun painting *A Gentle Breeze*. I took liberties changing the
color of the water to a complementary color scheme between
blue and orange and reflecting colors onto the bark of the tree.
I sprinkled table salt in the water area to depict movement on
the lake. My main goal was to make the shawl look as if it was
a thin, transparent piece of fabric. To achieve this, I painted wet-
into-wet using thin values of paint.

● *A Gentle Breeze*
Watercolor on 140-lb. (300gsm) cold-pressed watercolor paper
30" × 22" (76cm × 56cm)
Collection of the artist

art and family

Being an artist is a personal experience, yet it touches everyone around you. Family members can't help being impacted by the creative process and the time needed to create. My family has seen my artwork and my career evolve over the years. They understand the commitment it takes to constantly challenge myself as an artist. Artists are on a never-ending journey of creativity. The path might shift from time to time, but, no matter what is produced, it all relates to the creative process.

I was focused on my artwork in high school and college. Marriage and children pleasantly interrupted the completion of my college degree, but my creativity was still challenged with homespun media. My children grew up watching me paint on the ironing board or kitchen table while stirring soup on the stove or taking cookies out of the oven.

When our son, Nathan, was old enough to go to school, I returned to the University of Wisconsin Oshkosh. I created pottery for many years. When our daughter, Rachel, was in school, I went back to college to complete my B.F.A. It took me three more years, and our kids were twelve and eight years old when I finally received my degree.

Painting my family members includes them in the creative process. When I first asked my daughter-in-law, Karen, if I could take reference photos of her for future paintings, she was a bright, active participant. This was an excellent way to bring Karen into my creative world and to enrich my artistic vocabulary by painting a loved one from another culture. Karen's ancestors are from India, and I enjoyed painting her beautiful features.

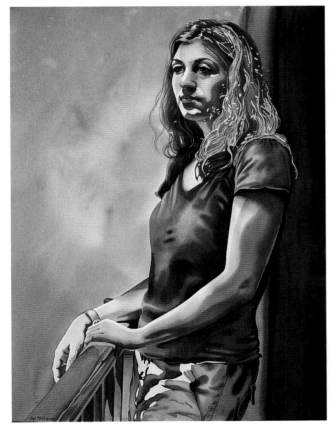

● *Sun Dappled*
Watercolor on 140-lb. cold-pressed watercolor paper
30" × 22" (76cm × 56cm)
Collection of the artist

creative holiday

In 2006, I organized a group art trip to Italy. We were lucky to have our daughter, Rachel, and our son, Nathan, and his wife, Karen, join us for two weeks of fun.

● *Karen II*
Watercolor on 300-lb. (640gsm) cold-pressed watercolor paper
15" × 30" (35cm × 76cm)
Collection of the artist

collage
painting

It's a good idea to push yourself by introducing new elements into your compositions. Mixing it up with collage is a fun and easy way to take your paintings to a different level of completion. The look is unique and your reward will be a renewed enthusiasm for completing a painting with totally new results.

Instead of using paint, you can use a variety of specialty papers to create different texture, then paste them on your composition.

Collage can be used in many ways—from saving a failed painting to creating a painting from the ground up. In this project, we'll resurrect a failed painting by introducing collage papers.

autumnal collage
Autumn in Wisconsin is a special time. Crisp cool air and fragrant leaves drying on the ground conjure up thoughts of harvesting maple syrup. I've always enjoyed observing the structures of trees after the leaves have fallen. Finishing this painting with a touch of collage paper added to the texture.

● *Maple Syrup Time*
Watercolor, ink and collage on 140-lb. (300cm) cold-pressed watercolor paper
15" × 22" (38cm × 56cm)
Collection of Jane Snider

The child is curious. He wants to make sense out of things, find out how things work, gain competence and control over himself and his environment, and do what he can see other people doing. He is open, perceptive, and experimental.

—John Holt

concepts & materials

paper types

I select papers that are sheer, semitransparent and opaque and have different textures. I choose colors that work with my palette colors. You can find a variety of collage papers at art supply and hobby stores as well as from art supply catalogs. Unryu paper has subtle texturing with long strands of rice fibers mingling with sheer paper. It comes in a wide variety of colors. Mulberry paper comes in thick sheets. It has noticeable fibers with little flecks of grass pieces and dried bits of leaves or tobacco. Thai Mango paper is also thick and features large pieces of fiber that look like flat twigs. The colors are quite vibrant and strong and add wonderful color notes to a collage. Ogura Lace paper has large, open holes that look like lace. The colors range from soft and pale to dark and rich.

using collage papers

The great thing about using collage papers is that you can work from light to dark or dark to light, unlike painting with watercolor. Some papers are transparent and others are opaque, which makes it easy to rework any area at any time during the project. For instance, if the papers are more transparent, you can keep applying sheer papers until you achieve the look you want. If your painting has an unwanted dark area, you can make it light by covering the area with a light, opaque paper. You can even add transparent papers to the composition if needed.

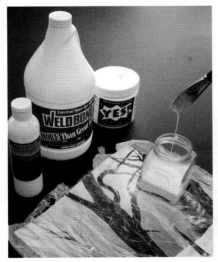

glues

When working with collage papers, the glue mixture should always be one-half glue and one-half water. The consistency should be similar to the half-and-half for your coffee. I use a variety of glues—Yes Stik Flat Glue, Weldbond and acrylic matte medium; they're all archival and dry clear. A container with a lid is helpful for storing any leftover glue.

collage papers

Here is just a sampling of the collage papers available. These are my favorite papers and they work well with my palette.

materials list

SURFACE
A partially completed or failed painting

BRUSHES
old 1-inch (25mm) flat for gluing

no. 2 rigger

no. 6 round

COLORS
Any watercolor or casein paints needed to enhance your painting. I used: Blue Sienna, Indigo, Permanent Violet Blueish, white casein

COLLAGE PAPERS
Thai Unryu: White (10 gram), Golden Green, Aubergine

Thai Mango: Brown, Rust

Ogura Lace: Lilac, Navy, Spring Green

Japanese Ethereal: Pink, Spearmint, Lilac, Sky Blue

ADDITIONAL MATERIALS
Yes Stik Flat Glue, acrylic matte medium or Weldbond adhesive, small container for mixing glue, Koh-I-Noor Nexus Studio Pen (black), Cretacolor Aqua Monolith watercolor pencils

1. Thai Unryu, Chiri
2. Mulberry Light
3. Tobacco Light
4. Mango, Navy
5. Unryu, Taupe
6. Thai Unryu, Golden Green
7. Unryu, Green Mist
8. Unryu, Chiri Amber
9. Unryu, Yellow Chiffon
10. Ogura Lace, Olive
11. Ogura Lace, Sky Blue
12. Ogura Lace, Brown
13. Ogura Lace, Blush
14. Ogura Lace, Plum
15. Ogura Lace, Spring Green
16. Unryu, Cream
17. Bamboo Light
18. Japanese Ethereal, Lilac
19. Japanese Ethereal, Pink
20. Japanese Ethereal, Sky Blue

saving a painting

In this project, you'll resurrect or save an incomplete or failed painting. You'll learn how to successfully glue collage papers without disturbing the paint underneath. You may need to touch up with watercolor paint and use a black pen for the final details.

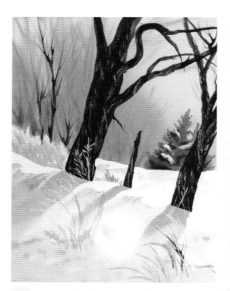

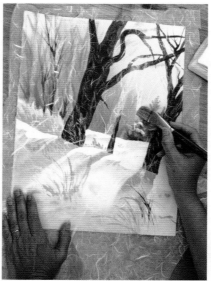

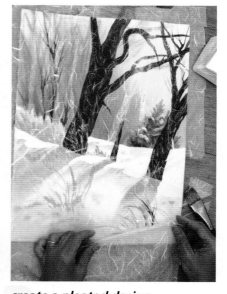

select a painting to collage

Choosing a painting that will benefit from the addition of collage papers is intuitive. Generally, if the painting will be enhanced with textures, it's probably a good candidate. I chose this unfinished painting for the project. I could complete it as a standard watercolor painting, but I think it could develop nicely if I incorporate collage for added interest. My goal was to use collage papers to create a dense forest in the background area, subdue the strong shadows on the snowbanks and enhance the swirling texture of the trees. The white Unryu paper will add a frosty effect to the winter scene.

glue paper over the painting

Mix Weldbond adhesive with water to create a glue mixture with the consistency of half-and-half. Place the white Unryu paper over the painting. If the paper extends beyond the painting's edges, you can easily tear the excess away after gluing. Using an old 1-inch (25mm) flat brush, glue over the top of the Unryu paper. The Unryu paper is thin enough for the glue mixture to soak through and bond with the watercolor paper. It's important to completely seal the watercolor painting by gluing the Unryu over the entire painting. Otherwise, you could see a glossy sheen from the glue. Make sure you have good glue coverage. If there are air bubbles between both surfaces, use a little more pressure with the brush to work them out.

create a pleated design

The Unryu paper can be glued down flat, or you can fold it into pleats to create an interesting design. Pleating the paper is like adding extra value because it has been overlapped and therefore thickened, strengthening the color.

right side up

Make sure you have the shiny side of the Unryu rice paper facing up and the dull side down while you glue. If the opposite occurs, the Unryu rice paper will appear more matte and look solid white rather than transparent.

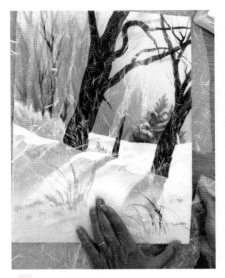

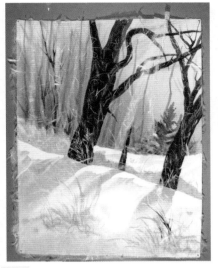

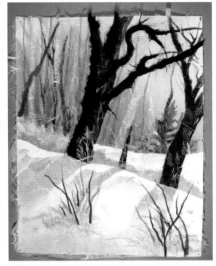

clean up the edges

Tear the excess Unryu paper away from the edge. Since it's wet from the glue, it will be easy to pull off the excess.

The painting has already been creatively altered with this first gluing. Some paintings might be complete at this stage, but we'll move along to learn more.

add more collage papers

Continue to add papers of different colors and textures to enhance the painting. I just tear the collage papers for a natural edge rather than cutting it with scissors. A cut piece of paper would add a hard edge not conducive to the landscape composition. Since the surface is still wet from gluing the white Unryu, I can keep gluing over the top with more papers. To add trees in the background, I glued Golden Green Unryu and Rust Mango. To separate the hill of snow from the snowfield in the background, I used Golden Green Unryu with bits of Spring Green Ogura along the top of the snow mound. I added a depth of color to the painted trees by gluing Aubergine Unryu and Brown Mango. I added some thin strips of Golden Green Unryu and Chiri Amber Unryu and pinched the strips together while the glue was still wet.

detail collage papers

Add more collage papers to develop the painting further. The same principles apply when using collage papers or constructing a traditional painting. The colors of the papers should be softer and paler in the background and more detailed and vibrant in the foreground.

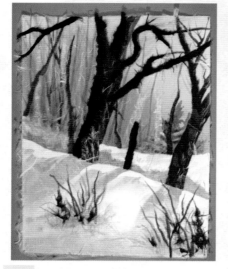
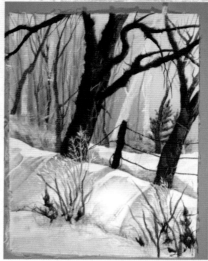
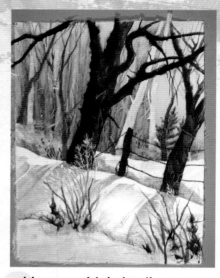

final collage papers

Add the final collage papers to complete this portion of the project. To counterbalance the large trees leaning to the right side of the composition, I added a branch of Aubergine Unryu at the top left side. This branch is extending from the main tree, which drops down from the top of the composition. To enhance the grasses in the foreground, I applied tiny pieces of Spring Green, Lilac and Navy Ogura Lace.

add paint

Adding paint is always an option. I first used Burnt Sienna watercolor at the bottom of the thicket behind the hill of snow. To heighten the shadow side of the trees, I combined Permanent Violet Blueish and Burnt Sienna and painted along the left side of the trees. I applied Indigo with a no. 2 rigger brush for the fence wires. I switched to white casein for an opaque coverage to recapture the frosted grasses in the foreground as well as make the birch trees more visible in the background. Since casein is a heavy pigment and quite opaque, it's beneficial if you need to apply light details over dark areas. A no. 6 round brush is handy for painting these tiny areas.

add pen-and-ink details

The collage/painting looks a bit ragged at this point. Fine-tune the composition by using the black Nexus Studio Pen to define edges and push areas into the distance. (See "Working With Ink" on page 42.) (I also used the pen to outline trees.) Stipple to define the pleated design. Continue to add pen work inside the grass thickets in the foreground, and enhance the shadow patterns on the snow.

roller-tip ink pens

These specialty papers consist of various coarse fibers. The fibers can damage the nib on nylon tipped pens, so try to use an ink pen with a roller tip, like the Nexus Studio Pen. This type of nib will roll the ink over the heaviest fibers of the specialty paper.

ink stippling

casein

watercolor
paint

watercolor
pencil

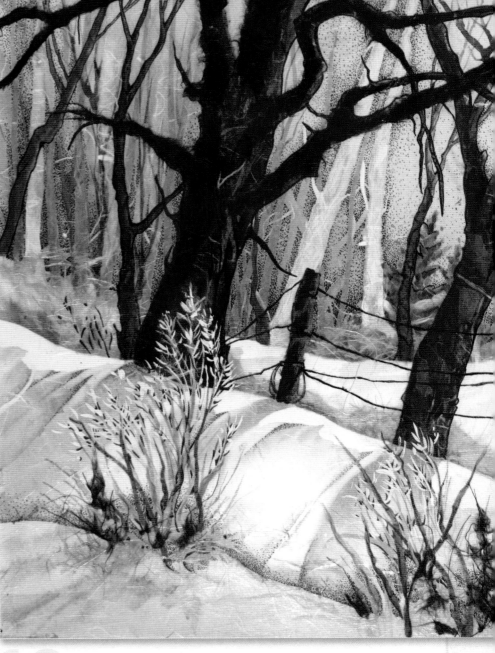

add final details

Step back to review your work. During my final critique of this project, I thought the largest tree was tilting too much, so I added some last-minute collage papers to the tree. I also added more paint to the tree next to the largest tree, which added more weight to that side of the composition. I added black ink inside the white seed pods of the grass to give them more emphasis. I finished up with a light, orange watercolor pencil on the shadow side of the birch trees in the background and used it to subtly highlight the fence post.

The addition of the collage papers brought life into the painting as it incorporated organic textures found in nature. The composition has more depth of field with a dense forest in the background, irregular trees in the mid-ground and natural-looking twigs and grasses in the foreground.

● *Early Frost*
Watercolor, casein, ink and collage paper on 140-lb. (300gsm) cold-pressed watercolor paper
15" × 11" (38cm × 28cm)
Collection of the artist

collage on gessoed hardboard

Hardboard is a high-quality, unprimed Masonite surface. Hardboard must be primed to accept watercolor, oil and acrylic. I enjoy gluing collage papers to it randomly and completing a painting by using watercolor or acrylic paint to capture shapes and forms.

featured surface

Richeson hardboard

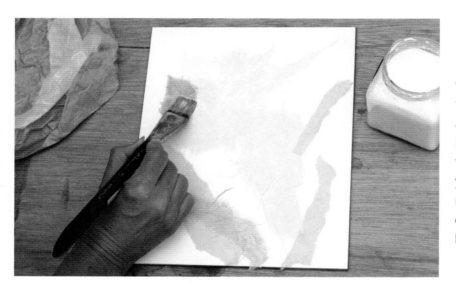

1 *glue the collage papers*
Prime the entire hardboard surface with acrylic white gesso. When dry, the collage papers will adhere nicely and create instant texture and color. I didn't draw on a composition, but feel free to draw on your subject if you want. I'm using the same glue mixture used earlier in this chapter: one-half water and one-half Weldbond adhesive.

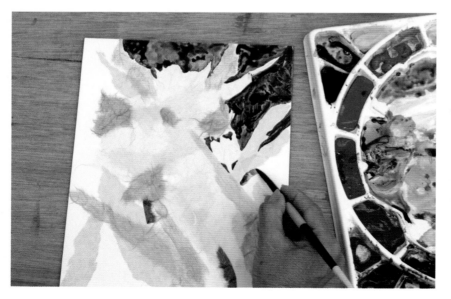

2 *paint the background*
Since gesso is on the surface, watercolor paint will look mottled. Colors will appear rich, bright and juicy since the gesso surface doesn't absorb the paint. The paint will roll around a bit on the surface and can be lifted off easily. The collage paper will absorb the paint. Start to paint the background areas using negative painting.

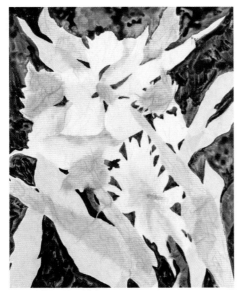

3 *develop the subject*

Using pigments that are the same color but slightly darker in value, develop the blossoms. Shade under the petals to suggest shadows and add form to the blossoms' centers. Painting the collage paper over hardboard is the *same* as painting on collage paper over watercolor paper. The advantage of using hardboard is the rich background that's painted on it. It's rich in color, mottled and liftable. Being able to frame the painting without glass is an added bonus.

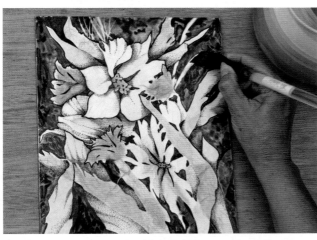

4 *detail with ink and lift paint*

Detail the blossoms with ink, stippling to contour the blossoms and leaves. Add background leaves and grasses by lifting some of the watercolor paint. Because the gesso is not absorbent, the watercolor paint will lift easily when completely dry.

5 *add finishing touches*

Using a palette knife, scrape a few more grasses into the background paint while it's still wet. Consider the painting. Do you need to add more texture using ink? The gessoed hardboard keeps the collage papers bright and colorful. The intensity of the dark background enhances the light, soft colors created by the collage papers.

● *Floral Cascade*
 Watercolor, collage papers and ink on Hardbord by Ampersand
 10" × 8" (25cm × 20cm)
 Collection of the artist

CHAPTER 14

collage
in bloom

Collage can merely add to a painting, or it can be the basis for one. In this project, we'll use a technique I like to call "painting with paper"—using collage papers to construct a painting, adding only a little watercolor for accent. I enjoy the quick results I can achieve by pasting large pieces of collage paper onto a white sheet of paper. The textures are immediate and bold. You can apply paint if desired, but the entire painting can consist of only specialty papers defined by ink-drawing methods.

painting with paper

Hot Tulips was created using a variety of colored collage papers. I used minimal paint to outline the flower and leaf shapes. I completed the painting by outlining the images with ink. You can see where purple and green collage papers were applied under the tulip color as an underpainting to add depth to the flower blossoms.

● *Hot Tulips*
Collage paper, watercolor paint and ink on 140-lb. (300gsm) cold-pressed watercolor paper
11" × 15" (28cm × 38cm)
Collection of the artist

The creative thinker is flexible and adaptable and prepared to rearrange his thinking.

—A.J. Cropley

concepts & materials

balancing warm and cool colors

The human eye wants to strike a balance between warm and cool colors. If a painting is dominated by warm colors, adding some cool colors will balance the composition. The reverse is the same, when a painting is heavy on the cool side, warm tones should be added for balance.

casein

Casein [kay'seen] is a fast-drying, durable aqueous medium that uses a milk-based binding agent. Ancient cave paintings using a mixture similar to casein have been discovered in Asia and Europe. Renaissance artists and the Old Masters also used casein. Many different effects can be achieved with this water-soluble medium. It can be painted thick to replicate an oil painting or thinned with water to mimic a watercolor. When dry, casein has a velvety, matte finish that can be buffed to achieve a satin sheen or varnished to resemble an oil painting. I use casein when a painting needs opaque coverage over dark colors. It adds another option to a traditional watercolor painting as well: It can be mixed with watercolor paint to create soft, velvety passages or a diffused, cloudy veil of color.

materials list

SURFACE
300-lb. (640gsm) cold-pressed watercolor paper

BRUSHES
old 1-inch (25mm) flat for gluing

no. 6 round

COLORS
Hooker's Green, Permanent Violet Blueish, Primary Yellow, Tiziano Red, Stil de Grain Brown, white casein

COLLAGE PAPERS
Thai Unryu: Salmon, Blue Chiffon, Green Mist, Forest Green

Japanese Ethereal: Lilac, Pink, Spearmint

Ogura Lace: Olive, Spring Green

ADDITIONAL MATERIALS
Yes Stik Flat Glue, acrylic matte medium or Weldbond adhesive, small container for mixing glue, Koh-I-Noor Nexus Studio Pen (black)

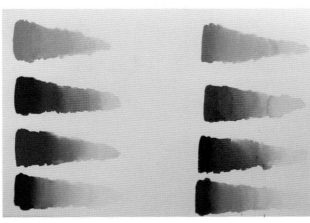

a versatile medium
Casein can be opaque or thinned to appear semitranslucent. On the left are swatches of casein in Yellow Ochre, Permanent Rose, Ultramarine Blue and Primary Green [Phthalo]. On the right side, are the same colors in watercolor.

opposites attract
This example illustrates warm color with a touch of cool added [left] and cool color with a touch of warm added [right]. I'm using the exact complementary color for the best color balance. It's not necessary to use the exact opposite color in all cases.

close-up on collage paper

Every Christmas my girlfriend Joanie Mosling gives me a new amaryllis bulb to force during the winter. When the flower is in full bloom, I draw many compositions onto watercolor paper for future paintings or collage work. I've chosen this closeup of an amaryllis because the flower petals are large, bold shapes with multiple blossoms coming from a single unifying stem. I can creatively play up the background to balance the flower and make it pop. I decided to switch the dark red amaryllis to a peach color since I had a new Unryu collage paper I was excited to use. Sometimes you just have to go for what excites you!

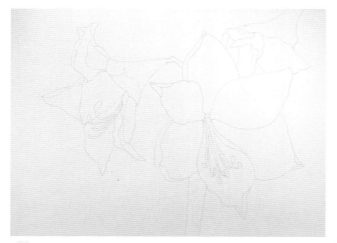

draw the composition

When drawing your composition, make the pencil lines a bit darker. The drawing needs to be seen through the many layers of paper that will be glued on top.

glue first paper layer

Since I want my flowers to be a peach color, I did an overall gluing using Salmon Unryu paper. I chose this paper because it is sheer with fibers woven into it, making it somewhat transparent. I pleated it a bit for interest. I also glued on several extra Salmon Unryu paper pieces for contrast.

develop the composition

Add a variety of colored papers to give the flower blossoms depth and contour. I chose Pink and Lilac Japanese Ethereal papers. I can diffuse these papers later by adding more paper or paint if they appear too bright. This doesn't have to be perfect. Your background papers will be placed last, so don't worry if the petal papers go over the pencil drawing; they'll be covered up. Start adding papers to the background now.

add detail

Sometimes a few interesting paper colors give the composition more excitement and variety. I added more Lilac Japanese Ethereal paper to the background and began to apply the Olive Ogura Lace behind the blossoms. This will develop into a textured background, leaving the blossom with a smoother look (and without adding texture between the flower and the background).

Gluing a different paper color over a collaged area has the same effect as glazing watercolor pigments: You get a mixture of the two colors. As with paint, you can create interesting neutralizations by using the complementary color, or you can disregard the base color, or even choose something dark and bold.

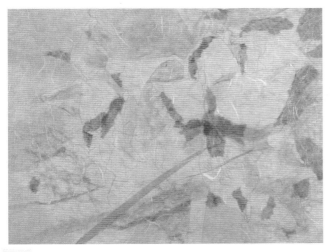

block in the background

I altered some of the peach color in the background by gluing over it with a neutral paper color, in this case, Blue Chiffon Unryu. The effect is similar to using a complementary color for glazing—the area is neutralized. Notice the Chiffon Blue that's glued along the sides of the stem. I'm actually negative painting with paper. I continue by adding darker textured papers to the background, such as the Olive Ogura Lace, creating a stronger value contrast.

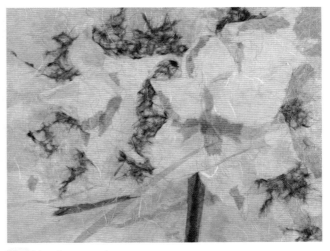

final background papers

Define the amaryllis blossoms by gluing darker papers around the edges of the petals, as if you were negative painting behind the blossoms. The fibrous texture of the Ogura Lace papers adds to the variation between the slick flower surface and the organic quality of the background. I kept adding depth to the background area by applying various layers of Olive Ogura Lace. I added Forest Green Unryu for the stem, overlapping the torn edge on the inside of the stem, leaving the cut edge along the sides of the stem.

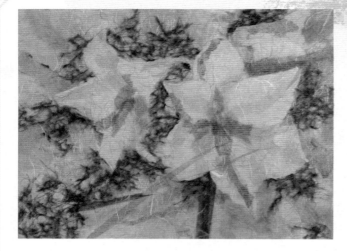

add final collage papers

Add the final collage papers to define the subject. Enhance the values, checking for good contrast between the lights and darks. I added more Salmon Unryu to contour the blossoms. I added Olive Ogura Lace to continue off the right side of the composition and to move it off the lower left corner.

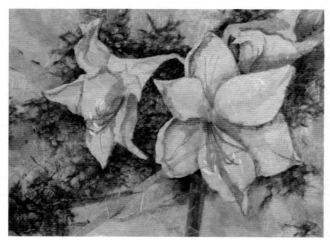

develop with paint

Adding paint is always an option. Painting with a no. 6 round, I fine-tuned several petals to boost the color as well as to create contrast and separation. Tiziano Red was a nice addition for the amaryllis blossoms. I used Permanent Violet Blueish in the background area for added contrast plus a bit of Stil de Grain Brown along a few edges of the flower. I used casein for its opaque quality to cover and stand away from the flower blossom. I mixed white casein with Primary Yellow for the tips of the anther portion of the stamens. I mixed Permanent Violet Blueish with casein for the inner portion of the pistil and stamen area. I switched this color to a combination of white casein and Hooker's Green for the ends of the cluster.

In general, it's easy to paint over large areas of textured paper but if you need to be exact (as in the pistil and stamen area) you need a steady hand and patience to paint the fine details.

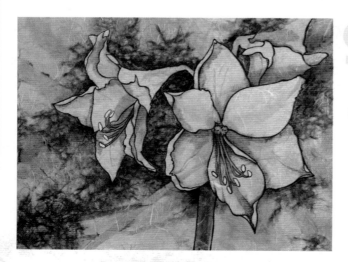

outline in ink

Use pen and ink to define areas of interest. I like to tidy up the edges of the blossoms by using a continuous line so the flowers look sharp against the background. I stippled the petal to develop its shape.

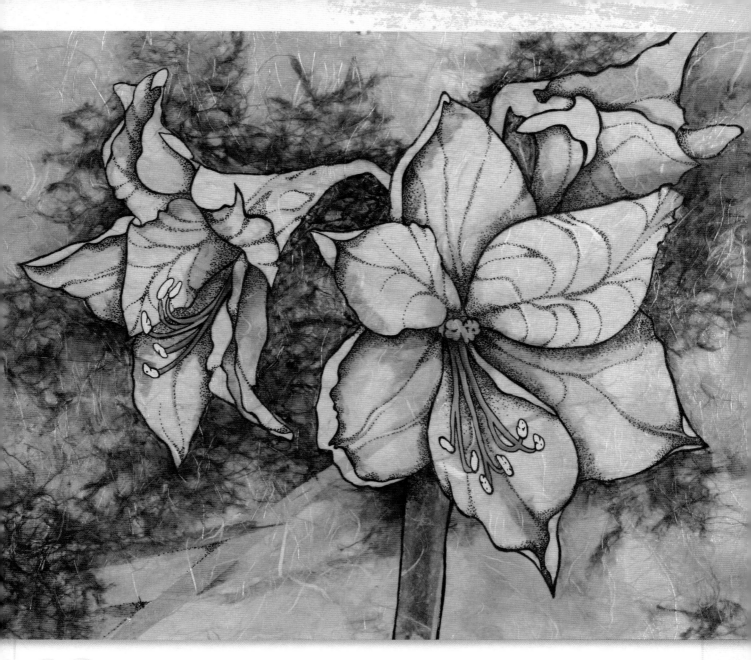

stipple the petals with ink

Stipple designs to suggest the petals' veining, as well as
areas of shadow. This helps describe the direction of each
petal, and adds a sense of depth.

• *Amazing Amaryllis*
 Collage paper, watercolor, ink on 140-lb. (300gsm) cold-pressed watercolor paper
 11" × 15" (28cm × 38cm)
 Collection of the artist

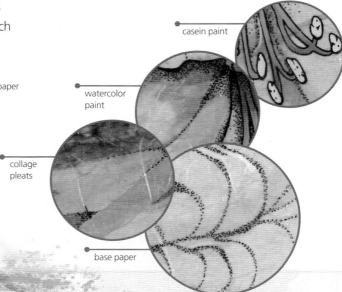

casein paint

watercolor
paint

collage
pleats

base paper

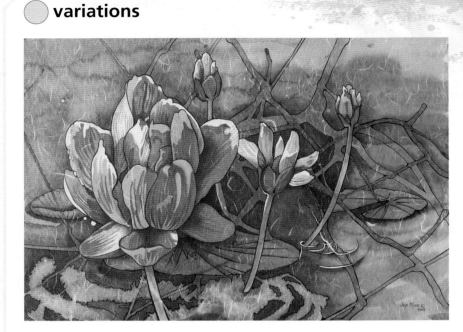

collage paper creates subtle color

This painting began as a poured water-color project. Once I removed the masking fluid, I thought I should tone down the color by adding some collage paper to the composition. I didn't want to disturb the graphic quality of the painting, so I glued an even piece of Unryu paper over the entire painting. I added circular torn pieces to the water area. I completed the painting by using ink to define the flowers and root system under the water.

● *Coral Water Lily*
Collage papers, watercolor and ink on 140-lb. (300gsm) cold-pressed watercolor paper
15" × 22" (38cm × 56cm)
Collection of the artist

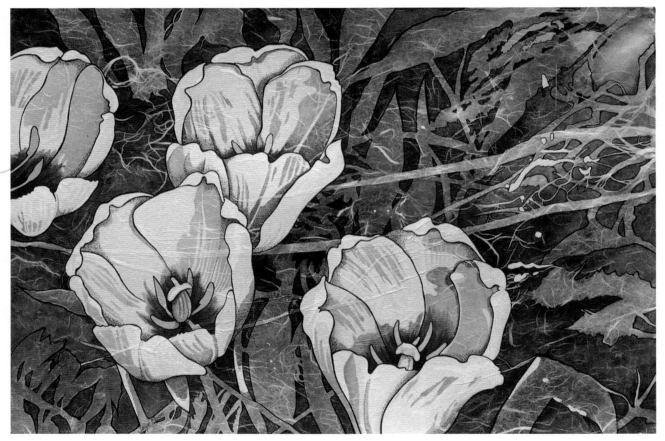

collage paper contributes to graphic quality

Yellow Tulips incorporates collage over a half-completed painting as well as negative painting and ink drawing methods. The pleated collage paper adds to the design quality of the composition.

● *Yellow Tulips*
Collage papers, watercolor and ink on 140-lb. (300gsm) cold-pressed watercolor paper
15" × 22" (38cm × 56cm)
Collection of the artist

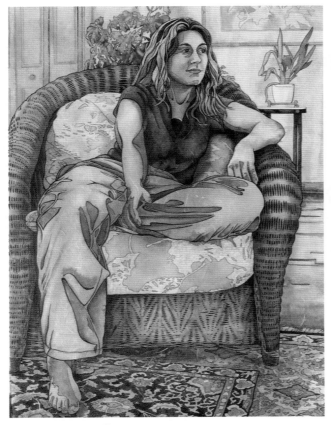

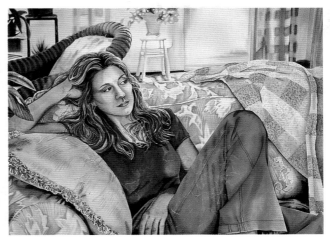

happy accident

I wanted to make the background in *A Quiet Afternoon* look as if the intense sunshine was melting some of the images away. I added the Unryu paper because the sizing of the paper had broken down and I needed to create a paintable surface so I could finish the figure. I took a risk and glued the Unryu paper over the areas that still needed completion. It worked and the twenty-five hours it took to paint the background was not lost. Art is just problem-solving!

● *A Quiet Afternoon*
 Watercolor and Unryu paper on 140-lb. (300gsm) cold-pressed watercolor paper
 22" × 30" (56cm × 76cm)
 Collection of the artist

an accepting surface

Looking at the Lake began as a standard watercolor portrait. The drawing took days to complete and for some odd reason the paper would not accept paint properly. I inked in all my pencil lines before I began gluing the white Unryu collage paper over the entire surface. This gave me a surface that would accept color. I completed the composition with another application of ink to define the figure and chair.

● *Looking at the Lake*
 Collage papers, watercolor and ink on 140-lb. (300gsm) cold-pressed watercolor paper
 30" × 22" (76cm × 56cm)
 Collection of the artist

collage creates nature's textures

River Aspens consists primarily of varied collage papers. I finished it with a touch of watercolor and black ink to define the landscape. This painting visually tells the story about textures found in nature through the collage papers used to create it.

● *River Aspens*
 Collage papers, watercolor and ink on 140-lb. (300gsm) cold-pressed watercolor paper
 22" × 15" (56cm × 38cm)
 Collection of the artist

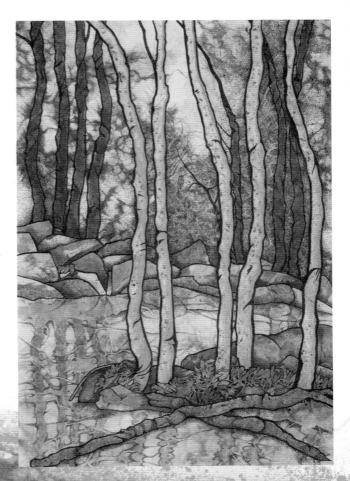

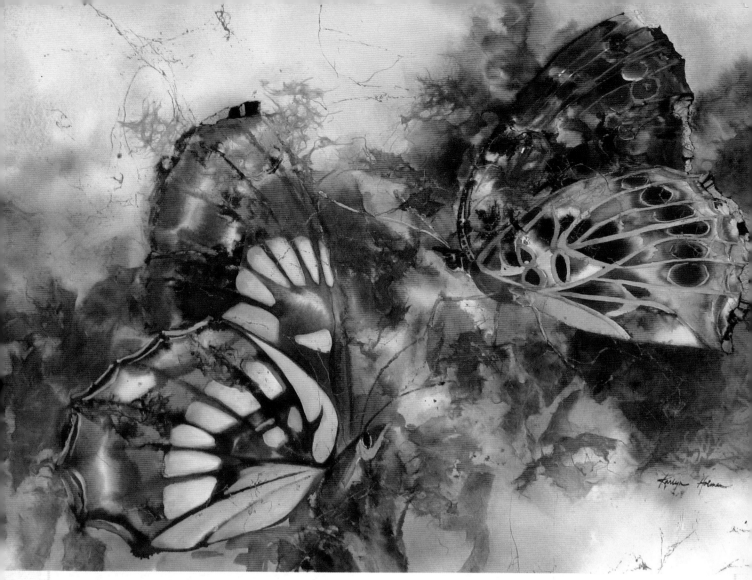

● *Butterflies*
Karlyn Holman
Watercolor and collage
22" × 30" (56cm × 76cm)
Collection of Amy Wichelt

afterword

Many years ago I discovered the artwork of Joye Moon and greatly admired her use of fresh color and her distinctive style of negative painting. To my surprise, Joye signed up for one of my watercolor workshops and our enduring friendship was formed. We now eagerly anticipate the occasions when we are able to spend creative time together and share our experiences as international tour leaders. Joye's passion for painting and her love of teaching come together in the pages of this book. I have no doubt that anyone who explores Joye's comprehensive and inspirational ideas will benefit from her years of experience and her deep commitment to her profession.

—Karlyn Holman

index

The best in fine art instruction and inspiration is from North Light Books!

ISBN-13: 978-1-60061-012-7
ISBN-10: 1-60061-012-9
Hardcover with concealed spiral, 160 pages, #Z1059

The approach to color theory in *Confident Color* makes selecting colors easy and efficient. Learning the importance of color schemes and color contrasts and how to use them effectively when painting will take your compositions to new heights. A lively illustrated color glossary provides a refresher on color basics so that you can focus on more complex theories.

ISBN-13: 978-1-58180-927-5
ISBN-10: 1-58180-927-1
Hardcover, 144 pages, #Z0568

Texture makes the difference between run-of-the-mill landscapes and paintings that spring to life. In *Creating Textured Landscapes with Pen, Ink and Watercolor*, pen and ink are used to add depth, impact and textural contrast—the key to realism in landscape painting. With the help of reference photos and field sketches, Claudia Nice shows you how to create realistic and colorful paintings of landscapes ranging from expansive mountain vistas to more intimate vignettes. Various components of landscape paintings are simplified and brought together throughout each chapter into full-page finished landscapes, giving you a goal to work toward. The tools and techniques are easy and fun to use, and the Claudia's informal and conversational instruction appeals to beginning and advanced painters.

ISBN-13: 978-1-58180-971-8
ISBN-10: 1-58180-971-9
Hardcover, 144 pages, #Z0757

Splash 10 features nearly 140 paintings from over 100 artists. Submissions by hundreds of watercolorists and water-media painters from around the world determine the content of each *Splash* title. Each painting is accompanied by a caption highlighting a specific inspiration, passion, tip or technique that offers instructive information about how it influences the painting. The theme "Passionate Brushstrokes" is both technical (encompassing the application of paint) and emotional (corresponding to the dedication and love of watercolor maintained by the contributors of the title).

These books and other fine North Light titles are available at

your local fine art retailer, bookstore or from online suppliers

or visit our website at www.artistsnetwork.com.